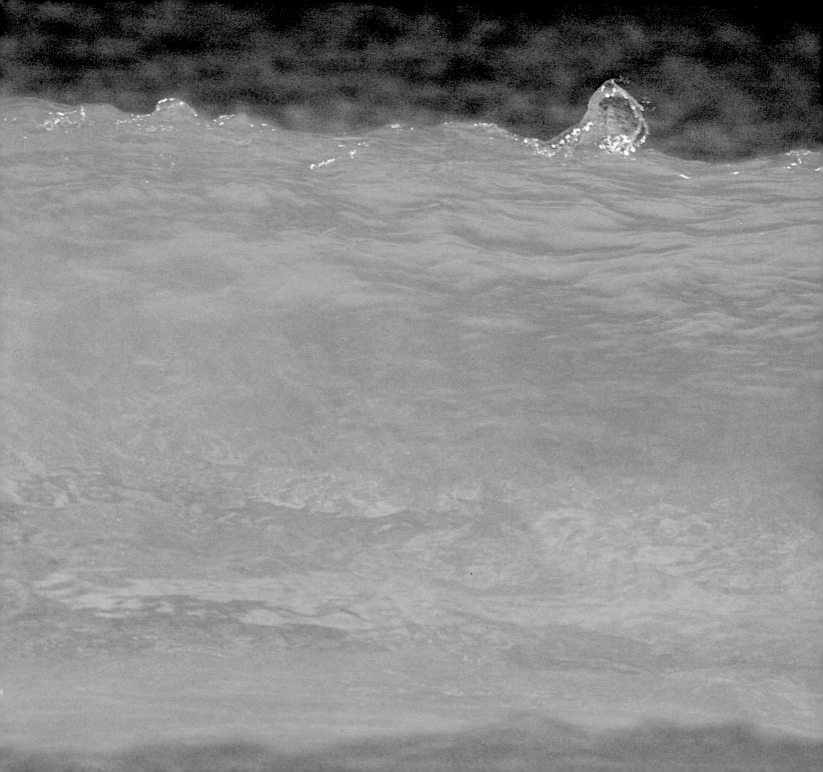

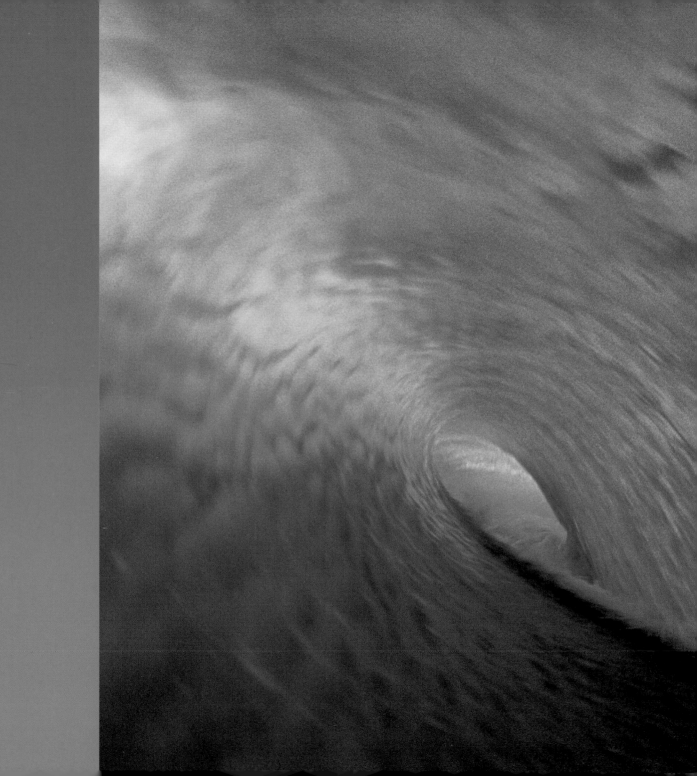

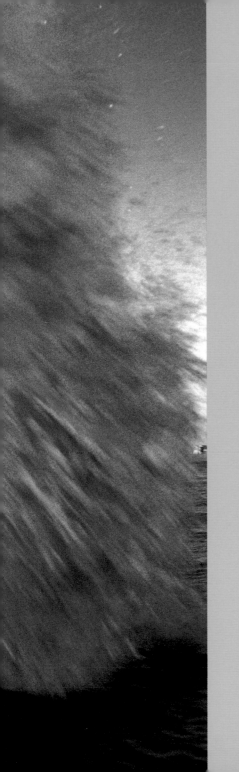

beaches

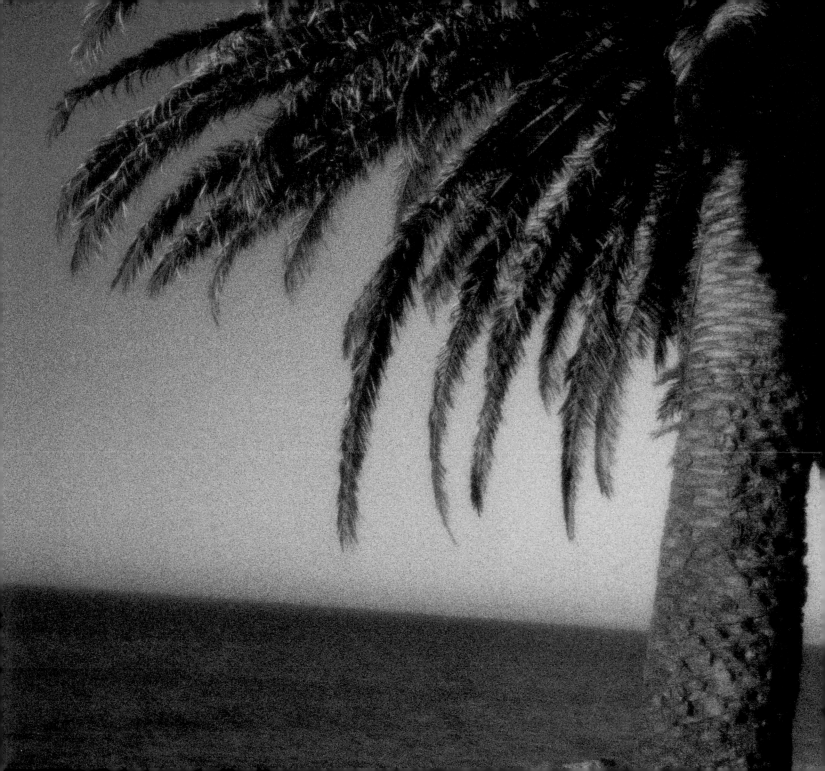

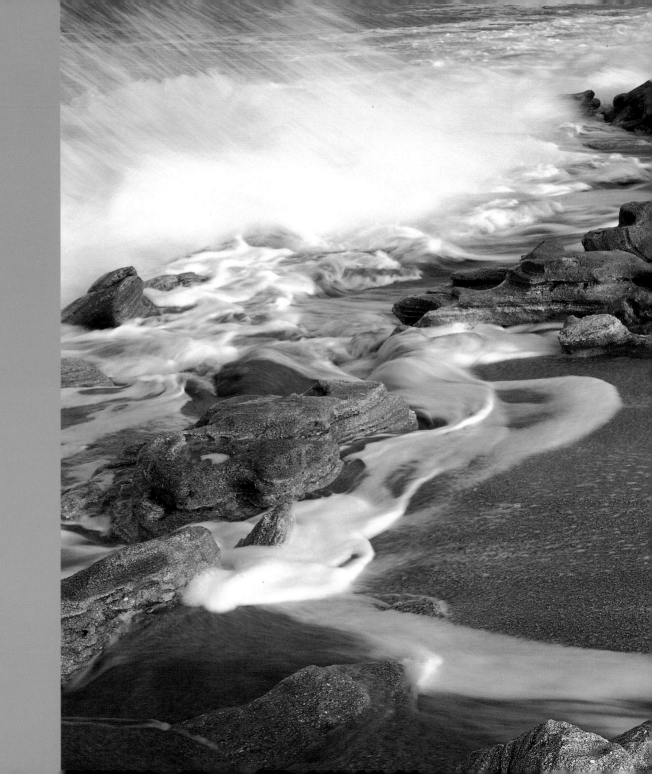

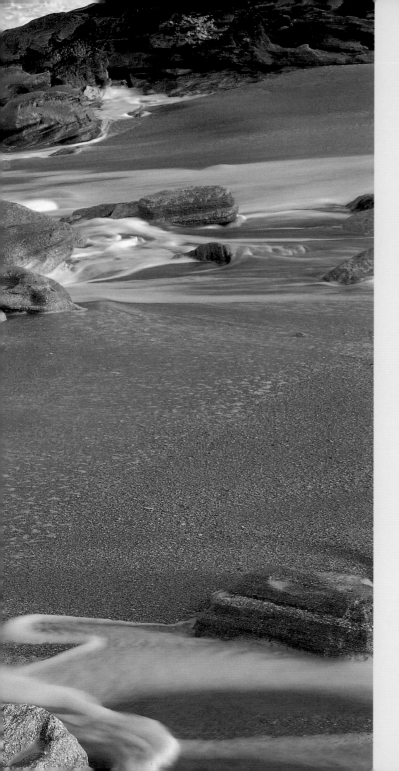

beaches

Lena Lenček and Gideon Bosker
with Mittie Hellmich

CHRONICLE BOOKS
SAN FRANCISCO

To Richard Pine, A Young Man of the Sea

Library of Congress Cataloging-in-Publication
Data
 Bosker, Gideon
 Beaches / by Lena Lenček and Gideon Bosker.
 132 p. 22.2 x 20.3 cm.
 ISBN 0-8118-2650-3 (hardcover)
 1. Beaches—Pictorial works. I. Lenček, Lena.
 II. Title.

 GB454.B3 B67 2000
 551.45'7—dc21 99-043804

Printed in Hong Kong
Designed by Laura Lovett
Typeset in Stempel Schneidler and CG Omega

Page 1: Pacific Ocean, South Point, Hawaii.
Half-title page: Pacific Ocean, Newport Beach,
California.

Page 5: Pacific Ocean, Montecito Beach, Santa
Barbara, California.

Title page: Shell Beach, Washington Oaks State
Gardens, Florida

Distributed in Canada by
Raincoast Books
9050 Shaughnessy Street
Vancouver, British Columbia V6P 6E5

10 9 8 7 6 5

Chronicle Books LLC
85 Second Street
San Francisco, California 94105

www.chroniclebooks.com

Acknowledgments

This book has required the cooperation, vision, encouragement, and creativity of many friends, publishing professionals, photographers, and editorial colleagues. First of all, we would like to acknowledge the photographers who agreed to contribute their work to this book. After hundreds of conversations and extensive correspondence with these artists, we were impressed with their passion for the beach and, especially, their enthusiasm for being part of a curated collection of images that captured the magic of where land meets sea. Without their vision and spirit of adventure, this book would not have been possible. We are also indebted to a group of editors and colleagues who, over time, have encouraged our study of the beach, and who have been instrumental in guiding our interest in this subject. In this regard, we are grateful to Bill LeBlond, Richard Pine, Hugh Van Dusen, and Wendy Wolf. Mittie Hellmich would also like to thank Janet Keating for her expert navigation down the Oregon Coast.

The process of taking an extraordinary number of images and assembling them into a book that captures the full visual and emotional range of the beach experience requires not only a personal interest in the subject, but the highest standards of design. We are especially grateful to Laura Lovett of Chronicle Books for creating a book that reflects the elegance, mystery, and visual palette of its subject matter. She has made this book sing on the page, and for this we would like to express our gratitude.

There are so many facets of putting a book together—among them, the look, feel, and content—that every project needs a captain. We would like to express our sincere thanks to Mikyla Bruder who, with diplomacy and panache, provided enlightened and meticulous guidance about all important aspects of the project.

Finally, we would like to thank Sarah Malarkey, our editor at Chronicle Books. It is stimulating to work with an editor whose vision is always one step ahead of yours, who knows how to capture the essence of an ambitious mission statement, and who knows how to combine paper, words, and ink into something that is far greater than the sum of its parts. When it comes to this rarified level of publishing, Ms. Malarkey is at the top of the heap. We express our deepest thanks for her counsel at every step along the way and for her commitment to this book from its inception to its final production.

G.B. and L.L.

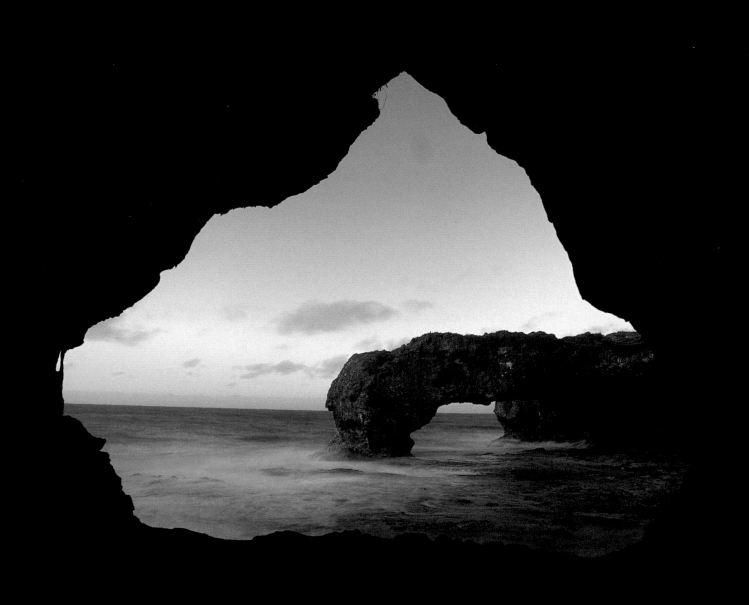

Introduction

What American reared on the childhood classic *The Wizard of Oz* can't relate to Dorothy's magical mantra, "There's no place like home"? Well, we have a confession to make. Beach bums from infancy, we were always skeptical about the strength of Dorothy's longing for the flat fields of Kansas because, for us, there could only be one place with the power to rock the soul and feed the heart—and that place was, and continues to be, the beach. On this unstable and dangerously seductive strip of land, the alluring alchemy of water, sand, wind, and light evokes in us sensations that collapse past, present, and future, sex and death, the sacred and the unholy, into a single, glorious experience of pleasure.

In the course of its evolution from a margin of civilization to the nerve center of human leisure, the beach yields an entire encyclopedia of information about culture and about how we humans organize our lives. The same configuration of land, water, and sky produces, on different edges of the same sea, entirely different types of architecture, customs and costumes. This is evident in the shapes and colors of our beach cabañas, parasols, and furniture; in the size and cut of our swimwear; in our shoreline rituals and foods; and even in the stories we read and tell at land's end. Over two millennia ago, Greek and Roman poets such as Homer, Sophocles, Ovid, and Virgil recounted tales of shores teeming with deities whose dispositions were as fickle as the weather, and whose moods were pegged to the forces that rule human lives. Only two hundred years ago, British and Continental romantics reinvented themselves

SOUTH PACIFIC OCEAN | *Talava Arches, Niue Island, Cook Islands*

as poetic geniuses on the beach, measuring the capacity of their minds and souls against the infinity of the sea.

If artists and poets mapped their psyches at the beach, their scientific colleagues, the geologists—the Neptunists and Plutonists of the eighteenth century—used the seashore to plot the physical history of the earth as a tale of ceaseless change and conflict. In the vivid striations of cliff faces and in the tumble of rocks and pillars at the scarred and broken edges of some land masses, the beach tells of timeless geological upheaval. The waves and the wind work tirelessly here, chiseling and polishing the rough drafts of the earth's endless redecoration schemes. Other forces are inscribed in volcanic sands, extruded from the earth's molten core in fiery flows of lava that cool and break down into nuggets of coarse black, red, and green sediment. In the great expanses of the Pacific, strings of coral atolls compose a script of squiggles, commas, and rings that reflect the slow, steady production of sand from the calcium carbonates of organic microorganisms. The powdery shores and boulder-strewn borders of inland lakes record the ancient violence of glaciers gouging and scraping the earth in their passage across the land. With their extraordinary geological and biological diversity, the world's beaches are true microcosms of our planet and of the forces and processes that shape it.

Although we have always carried a camera during our travels to the beach, we have failed miserably in our attempts to produce an evocative set of photographs that encompass the full emotional range of places where the land meets the sea. Over time, however, we came to realize the reason we failed is that capturing the quintessential personality of the beach requires a virtuosity compounded of many eyes, perspectives, and photographic techniques. Only a consortium of inspired artists, each with his or her own specialized vision and interpretative skills, can extract the visual sweetness and light of the seashore and tap into the range of its visual delights.

The beach, after all, is among the most challenging and rewarding of photographic subjects, because, suspended between the immobility of the land and the fluidity of water and sky, it offers a vast volume of information. Accordingly, rather than being conceived in full, this book evolved, like the seashore itself, into a chronicle that presents the beach in all its moods, complexions, and inflections. The photographs reproduced on the following pages have been selected from the archives of the world's best photographers, most of whom have devoted their lives and imaginations to capturing the essence of beach. We estimate that the photographers included in this book have traveled more than twenty million miles to remote beach destinations across the globe, spent thousands of lifetime hours photographing them, and have taken more than sixty thousand images of sand and sea in order to create this comprehensive chronicle.

If there was a single principle guiding the selection of images, it was the idea that these photographs should reveal how the beach might see itself if it were to ponder its own face without the intermediary of the human eye. To illustrate the shore's remarkable range and fluidity, we have chosen, from among more than five thousand world-class images, the most crystalline, intelligent, and evocative portraits of the beach we have encountered in more than ten years of researching, traveling, and writing about this subject. Although the majority of photographs focus on ocean shores, we also include images of the beaches that line estuaries, rivers, and lakes.

The result is a collection of photographs that reflects a stunning range of visual sensibilities. Some images are so subtle that one can barely register the faint transition from sky and water vapor to sea and sand. Others are so dramatic, with their screaming colors, climatic energy, and complex composition, that one inadvertently squints and draws back from the page. Taken as an ensemble, the sequence of photographs is intended to re-create the sensation of watching a silent movie: each page offers another frame that transports the viewer to

a new place, each characterized by yet another evocative and unanticipated merging of sand, sea, and sky.

What is most extraordinary about this compendium is the recognition that, despite the countless ways in which we have seen the beach express its visual diversity, there are so many more remarkable combinations of light, water, earth, clouds, and sky than we could ever have imagined were possible. This chronicle confirms both that the beach is inexhaustible in its variations of color, mood, and topography, and that, no matter how nuanced and ambitious a collection of images may be, it will always grant the beach the courtesy of having the last word.

These photographs address each one of us directly, unlocking profoundly personal memories, associations, and impressions. For this reason, we did not wish to interject our own thoughts in the form of a commentary. Instead, we wanted the images to speak for themselves. Accordingly, we have included brief, factual notations throughout the book. These are intended to offer scientific, historical, and factual information that will enhance the pleasure of the eye without interfering with the viewer's emotional experience. After all, the beach is the place to which we come, in the words of Lord Byron, "To mingle with the Universe, and feel/What [we] can ne'er express, yet cannot all conceal."

In our view, this tapestry of images is a confirmation of the depth of feeling and wonder that lie at the very core of the beach experience. If, in turning the pages of this book, the reader catches the phantom perfume of the sea, then we will have succeeded in our goal.

LENA LENČEK AND GIDEON BOSKER

BIRD ISLAND BASIN | *Padre Island National Seashore, Texas*

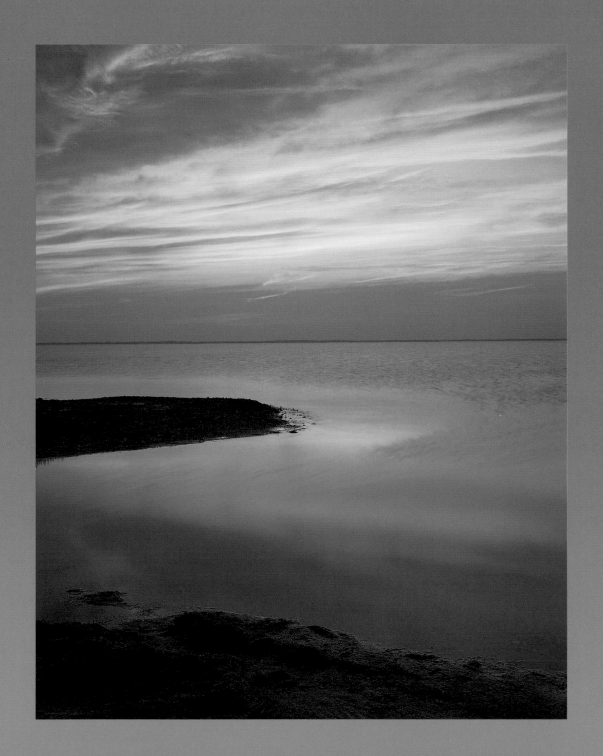

PYRAMID LAKE | *Pyramid Lake Indian Reservation, Nevada*

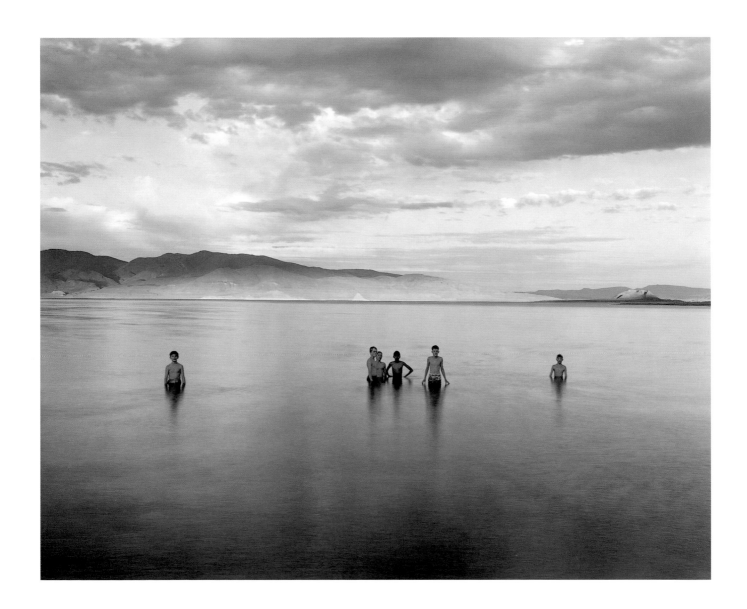

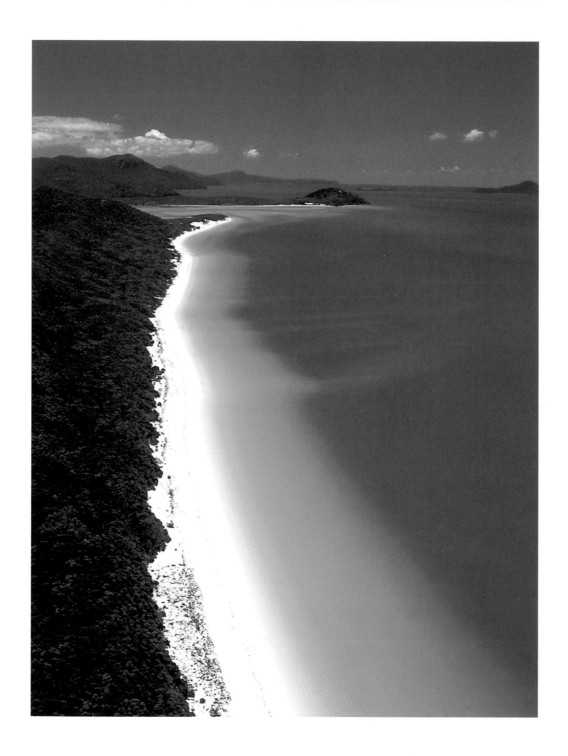

The beach is more than the stretch of dry sand between land and water on which we spread our towels. Technically, that strip is called the back shore, and it is merely one segment of a complex system—part geological, part ecological—that extends all the way from the edge of the land to a point beneath the surface of the waves offshore. Geologists have a name for each portion of this distance. The ridge that marks the highest point waves normally reach is called the berm, and it defines the line of demarcation between the back shore and the foreshore, or beach face. The foreshore is the intertidal zone, which is alternately exposed and covered, depending on whether the tide is in or out. Beyond that lies the shore face, which extends underwater for a distance of several feet to several miles. Its outer limit is reached at the point where water can no longer move gravel, sand, or sediment. In the case of gravel, this is at 120 feet of water; in the case of sand, at 180 feet, or the thirty-fathom line.

PACIFIC OCEAN | *Whitsunday Island, Australia*

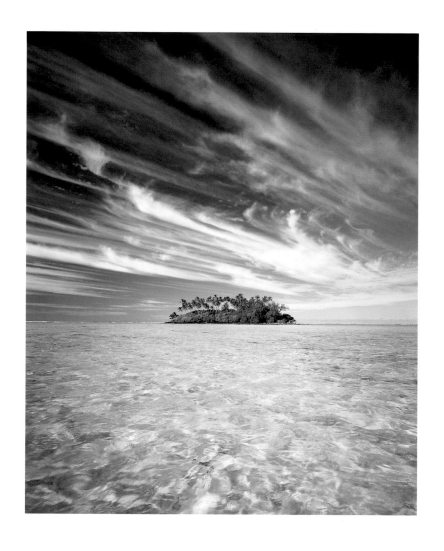

SOUTH PACIFIC OCEAN | *Taakoa Island Lagoon, Cook Islands*

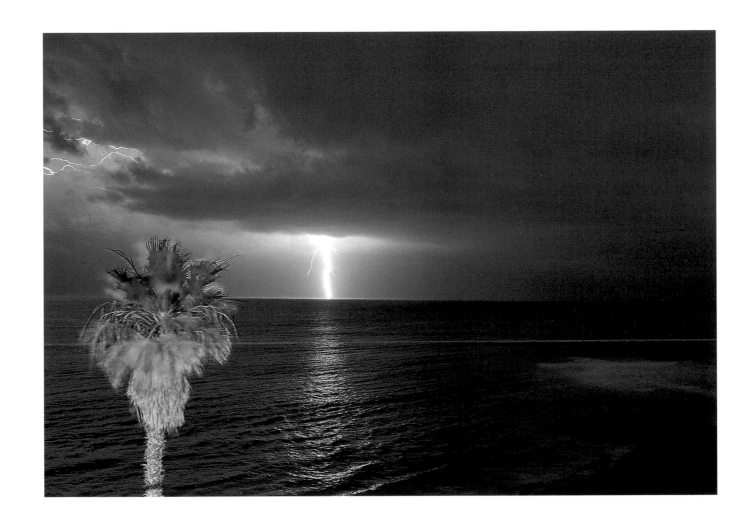

PACIFIC OCEAN | *Swami's, California*

Though no one knows precisely when South Seas islanders began to ride the waves to shore on wooden planks, surfing historians speculate the sport originated some three or four thousand years ago. As practiced by the peoples of Oceania and especially the islanders of eastern Polynesia, surfing was not just a casual pastime, but a culturally significant activity with its own rituals, rites, and protocols. Early European explorers such as Captain James Cook and Captain William Bligh first encountered surfing in Tahiti in 1778 and 1789 and were captivated by the skill and beauty of the sport. Although nearly stamped out of existence by Christian missionaries, who found it ungodly and responsible for the "destitution, degradation, and barbarism" of the indigenous peoples according to an 1820 report by the Calvinist minister Hiram Bingham, surfing began to reappear in Hawaii early in the twentieth century. Much of the work of reviving the sport came from young *haoles,* the sons of Hawaii's nonnative twentieth-century settlers, who picked up the moves from the handful of natives still surfing off the beach at Waikiki. A major impetus came from a story on the "royal sport" of surfing written by Jack London, who glamorized the image of the surfer as a pagan deity. Writing in *The Cruise of the Snark,* London described an indigenous surfer as "erect, full-statured, not struggling frantically . . ., not buried and crushed and buffeted by those mighty monsters [of waves], but standing above them all, calm and superb, poised on the giddy summit, his feet buried in the churning foam . . . flying through the air, flying forward, flying fast as the surge on which he stands. He is a Mercury—a brown Mercury. His heels are winged, and in them is the swiftness of the sea."

INDIAN OCEAN
Bluff Point, Australia

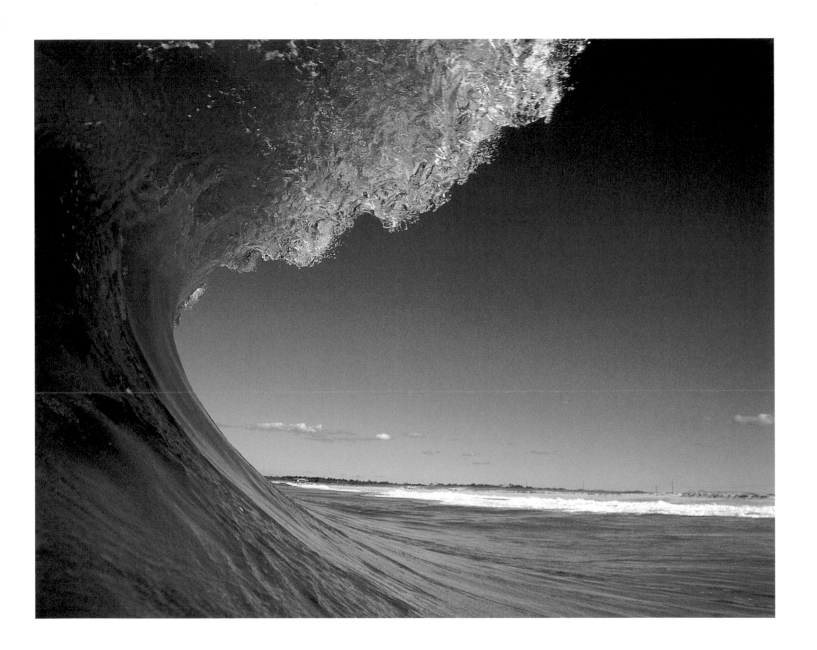

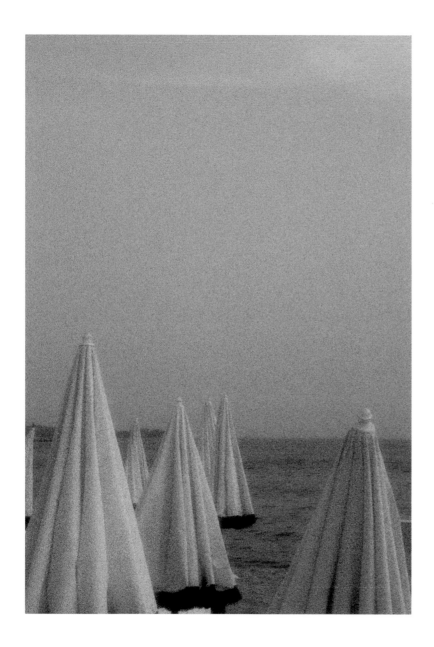

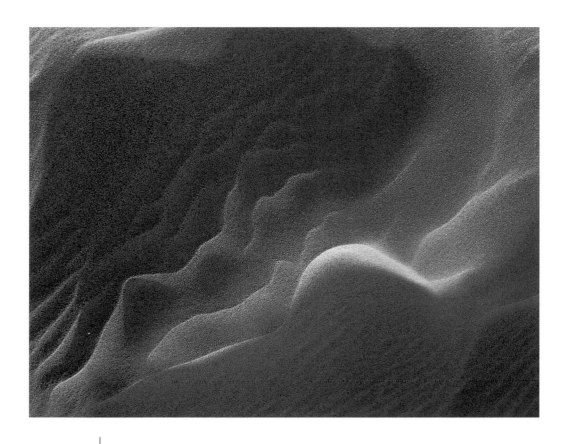

DUNE | *Oceano, California*

MEDITERRANEAN SEA | *Cannes, France*

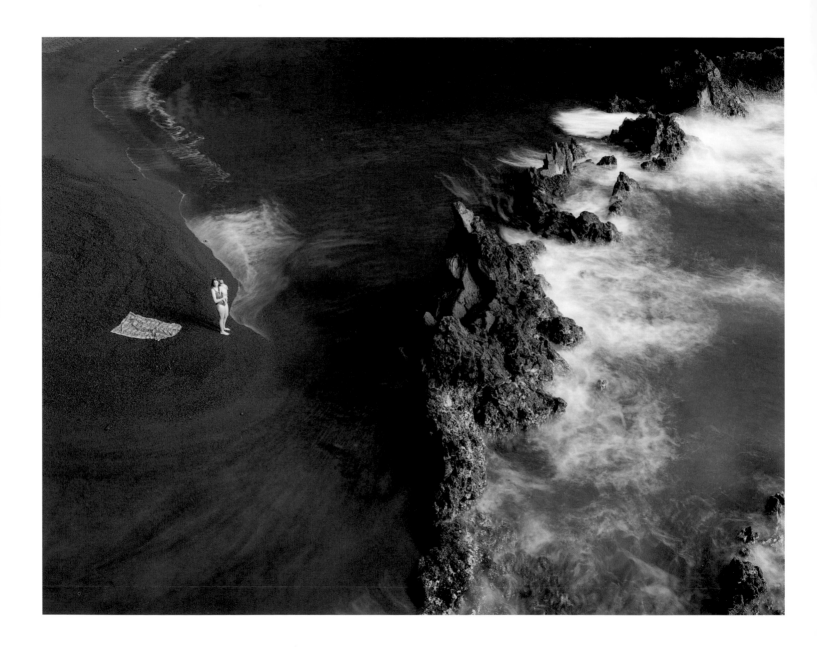

Derived from diverse minerals and substances, sands come in a paint box of colors, ranging from tan, yellow, white, and pink to purple and red, and even to blue, green, and black. Color is one way to determine a sand's origin. In the United States, for example, the whitish sediment along the northeastern coast comes from ancient rivers and the primordial scourings left by migrating glaciers. Below North Carolina, the sand begins to take on a pinkish and yellowish tint because of the calcium carbonates of crushed seashells. Sand on the Florida peninsula's Atlantic side is grayish quartz, but on its tip and western shore it is grainy and white, and is composed of the skeletons of marine animals. The powdery beaches of the Gulf Coast are stained pale pink with the shells of shrimp and conch, and yellow and orange from the copper, calcium, and quartz washings that the Mississippi river basin drains from the Appalachian highlands and the Great Plains. In tropical waters, the hues are even more theatrical, especially in beaches of volcanic origin. Hawaii boasts the green olivine sands of Papakolea Beach (Big Island), the cinder-cone reds at Hoku-'ula (Maui), and the jet black of Polulu Beach (Big Island).

PACIFIC OCEAN | *Kaihaluau Beach, Hawaii*

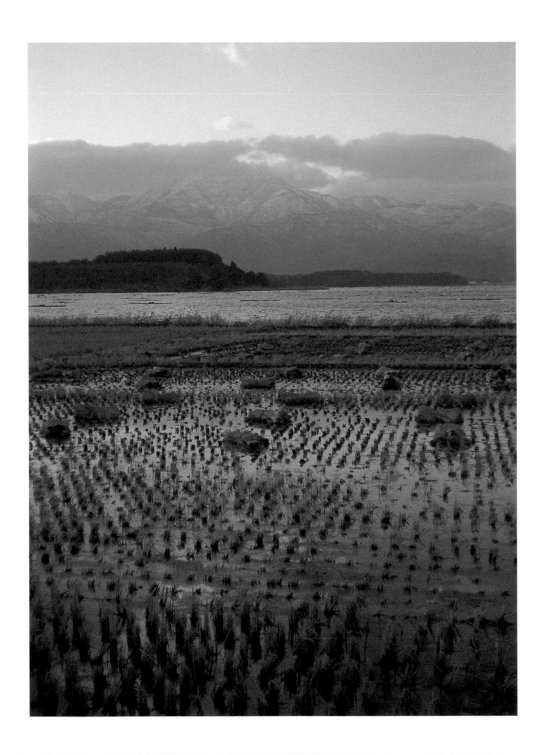

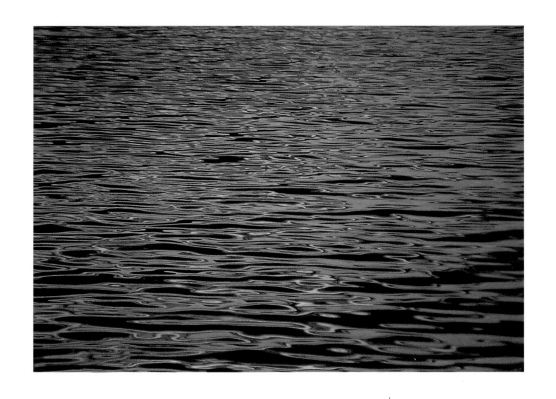

SOUTH PACIFIC OCEAN | *Komodo, Indonesia*

SEA OF JAPAN | *Sado Island, Japan*

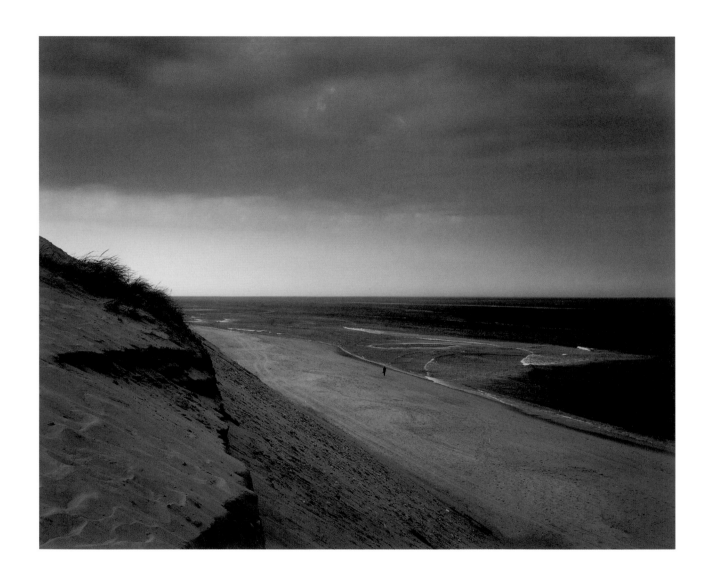

ATLANTIC OCEAN | *Longnook Beach, Massachusetts*

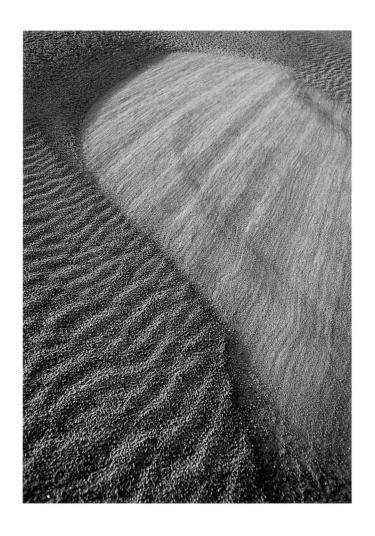

SEA OF CORTEZ | *Baja, Mexico*

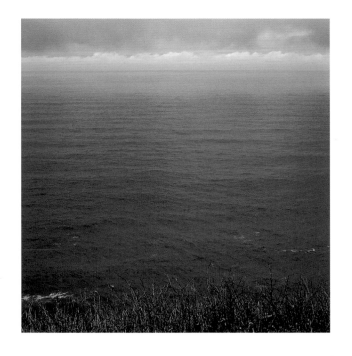

PACIFIC OCEAN | *Florence, Oregon*

INDIAN OCEAN | *Sri Lanka*

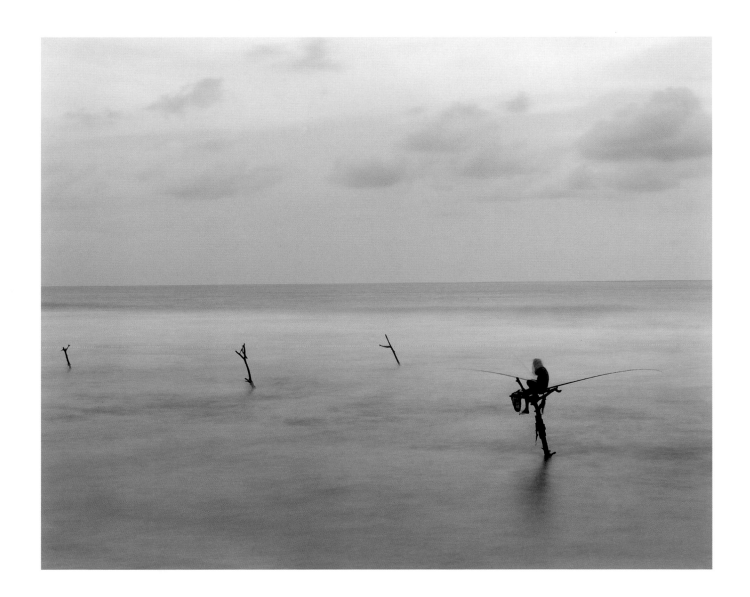

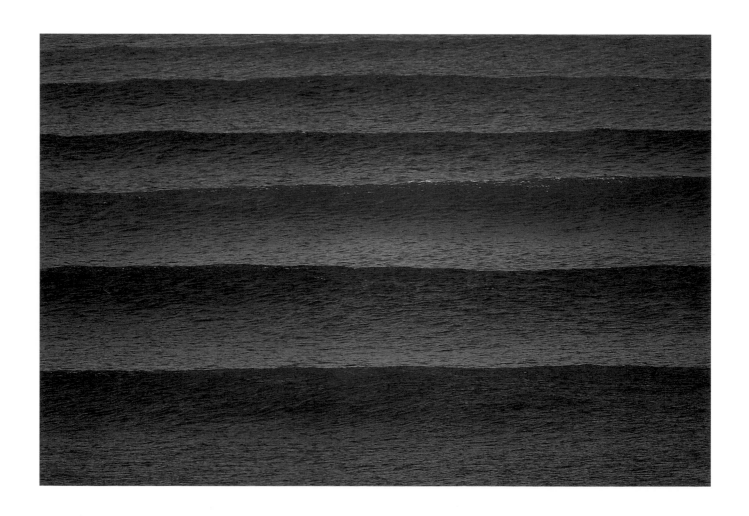

The waves that break on the beach usually originate far out at sea. They are generated by the wind; atmospheric pressure gradients; seismic incidents such as earthquakes, explosions, or landslides; or by the friction of waters of different densities and temperatures that register on the surface as alternating bands of ripples and slicks. Most wind-driven waves have a pyramidal shape with a steep face and a long, sloping back. They begin their life with a slap of the wind passing over still water. When the tiny air particles collide with the water molecules, they break the surface tension, furrowing it with alternating grooves and ridges. A gentle breeze raises tiny ripples or capillary waves known as "cat's paws." These tiny ripples, in turn, snag more of the wind's energy and ripen into wind *chop,* which if augmented by fresh agitation, assumes a confused, irregular pattern called a *sea.* How high the waves will eventually develop depends on the *fetch,* the distance the waves can run without meeting an obstacle. The stronger the wind and the longer the fetch, the bigger the waves, which is why really big waves cannot be produced in the confines of a bay. As soon as waves move beyond the reach of a driving wind, they lose their peaked shape and become *swell*— long, low, and rounded. Swell moves swiftly through the ocean for thousands of miles until it becomes *breaker* as it approaches the shore.

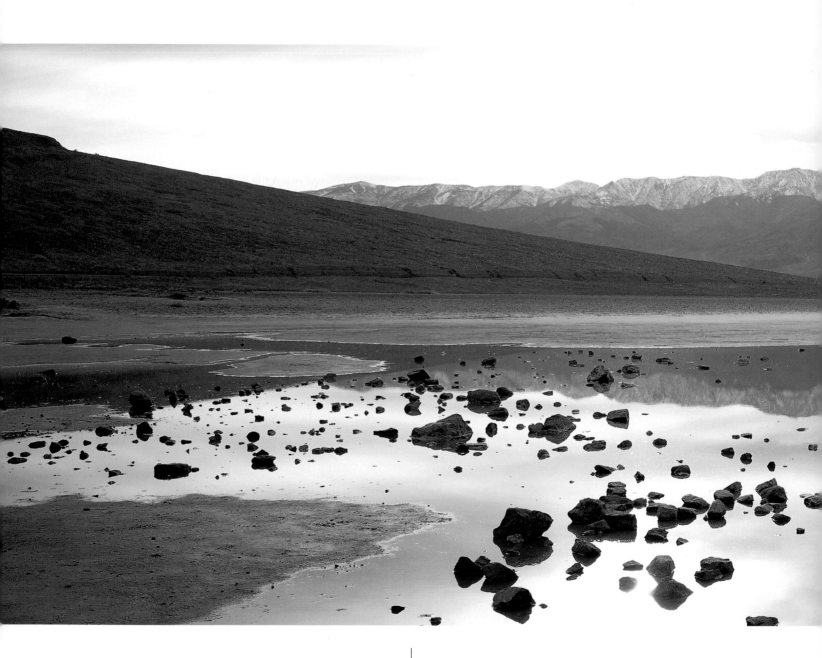

SALINE LAKE | *Death Valley, California*

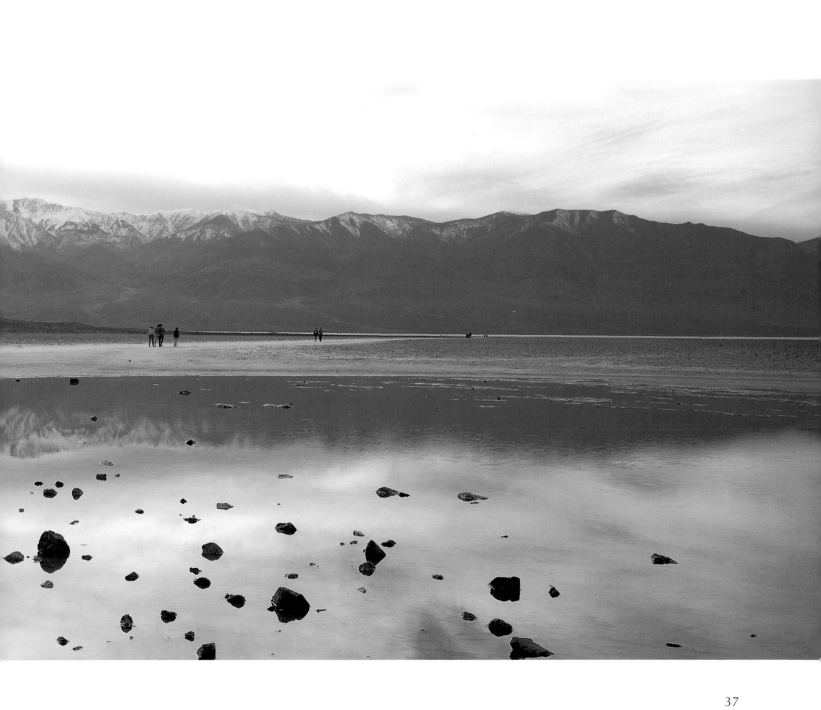

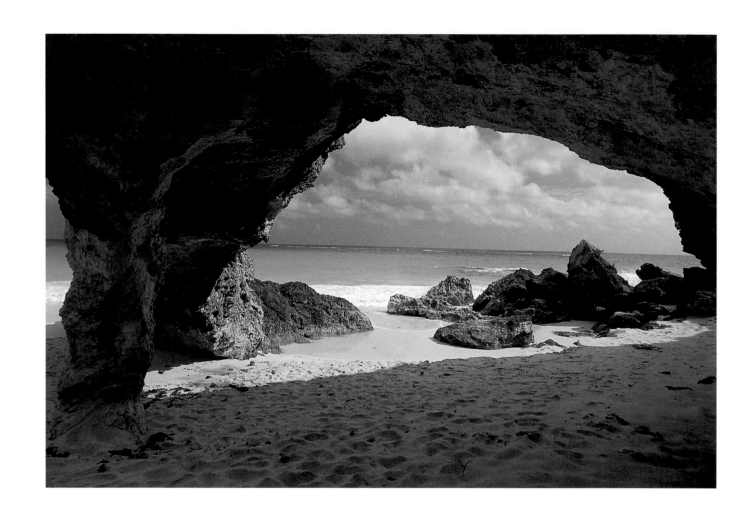

ATLANTIC OCEAN | *Natural Arches, Bermuda*

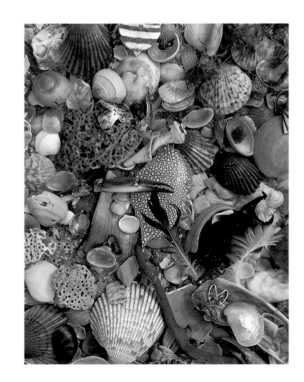

SHELLS | *Hatteras Island, North Carolina*

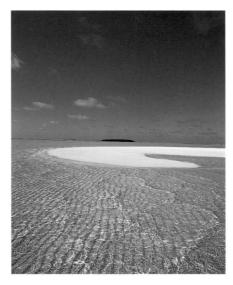

Most of the world's white beaches derive from carbonates that many thousands of years ago made up the bones and shells of marine creatures. The blinding white beaches of the Florida Keys and the Caribbean are composed of the finely ground skeletons and shells of submarine creatures from the tropical seas: corals, mollusks, crustaceans, fish, and even plankton. The sands of Miami Beach, the atolls of the South Seas, and the beaches of the Indian Ocean are nothing more than burial mounds of expended sea life. Viewed with a microscope, calcium carbonate sands reveal myriad distinctive shapes: stars, asterisks, spheres, platelets, boomerangs.

SOUTH PACIFIC OCEAN | *Tahiti*

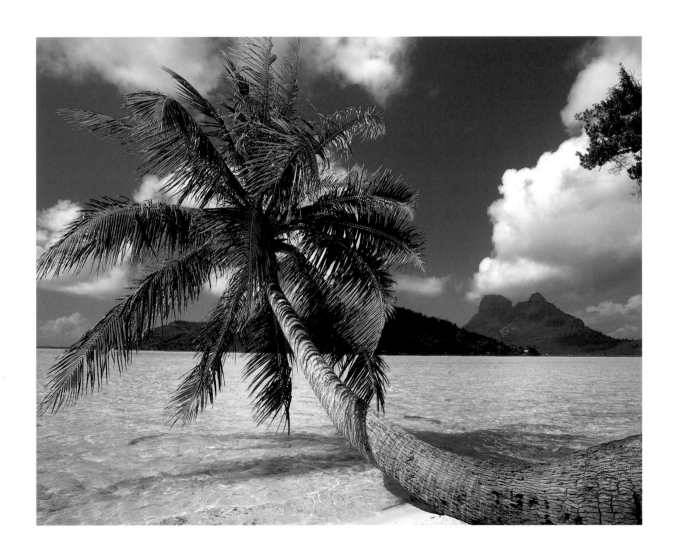

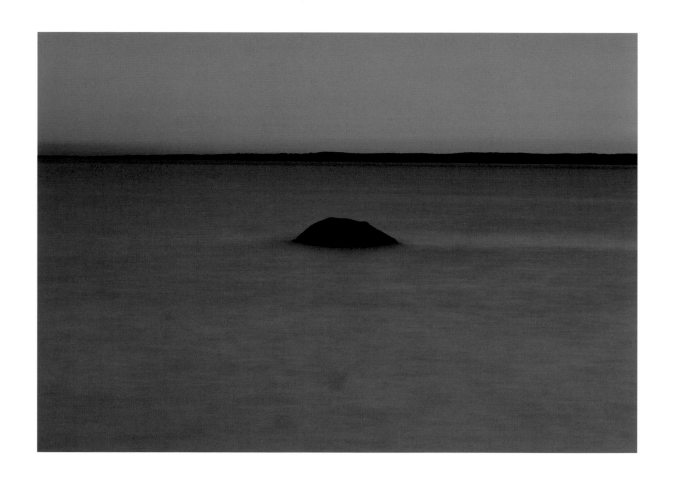

VINEYARD SOUND | *Martha's Vineyard, Massachusetts*

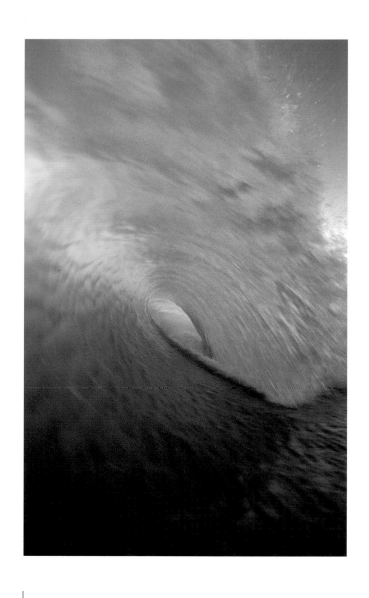

PACIFIC OCEAN | *Newport Beach, California*

The more unyielding the face that land presents to water, the more violent is the force of waves breaking against it. Even in fair weather, the waters off Scotland, or off the northeastern and northwestern United States, hurl themselves against the rocky shore, jarring boulders and scooping up cobbles. The power of the waves lofts stones high into the air and smashes them against each other with a constant, percussive clacking and booming. The advancing wall of water forces air back into microscopic fissures in the rock, prying apart fault lines, chipping at outcroppings. The waves retreat, hauling their loads of rock along the sea bottom until the next swell rushes in, exerting thousands of pounds of hydraulic and pneumatic pressure per square inch. The work of breaking, grinding, and reconfiguring coves, promontories, and headlands continues unabated through the fierce storms of winter and the mild days of summer.

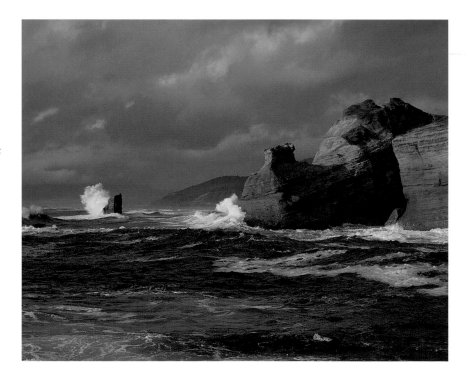

PACIFIC OCEAN | *Cape Kiwanda, Oregon*

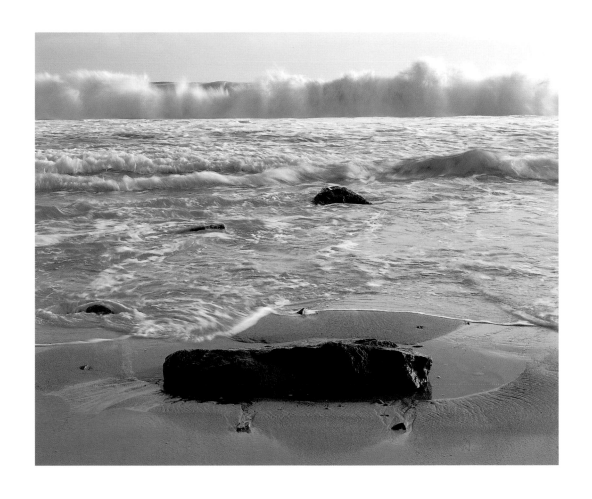

ATLANTIC OCEAN | *Cape Cod, Massachusetts*

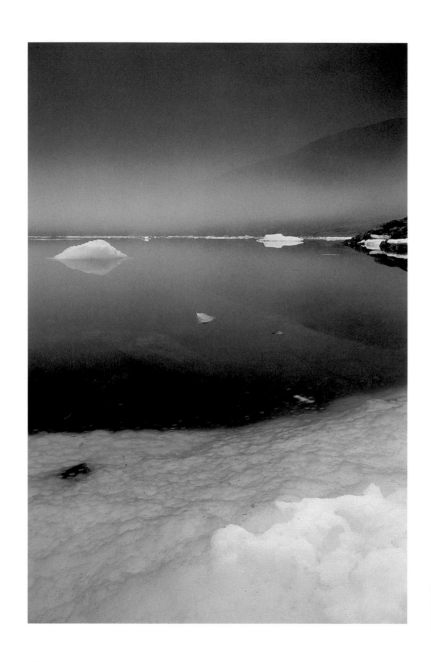

ARCTIC OCEAN
Ellesmere Island, Canada

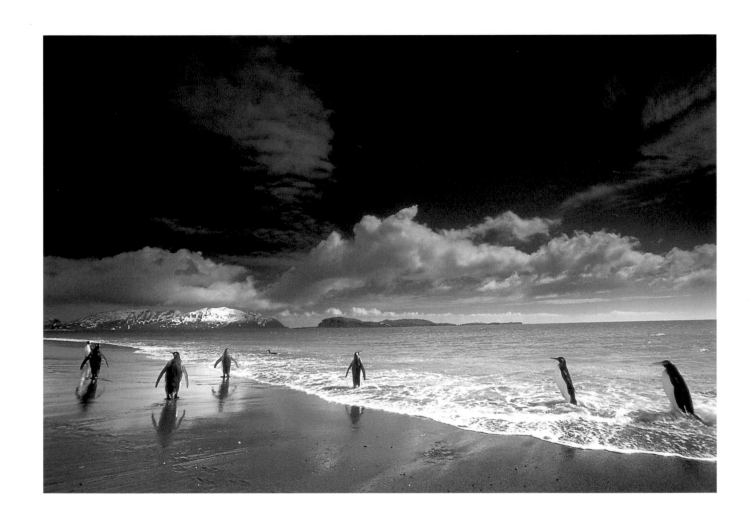

SCOTIA SEA | *South Georgia Island, Antarctica*

GULF OF MEXICO | *Horn Island Wilderness Area, Mississippi*

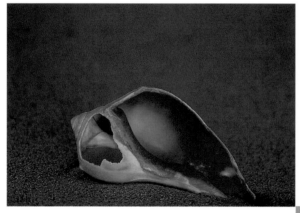

SHELL AT SUNSET
Cape Cod, Massachusetts

TIDAL FLAT
Assateague National Seashore, Virginia

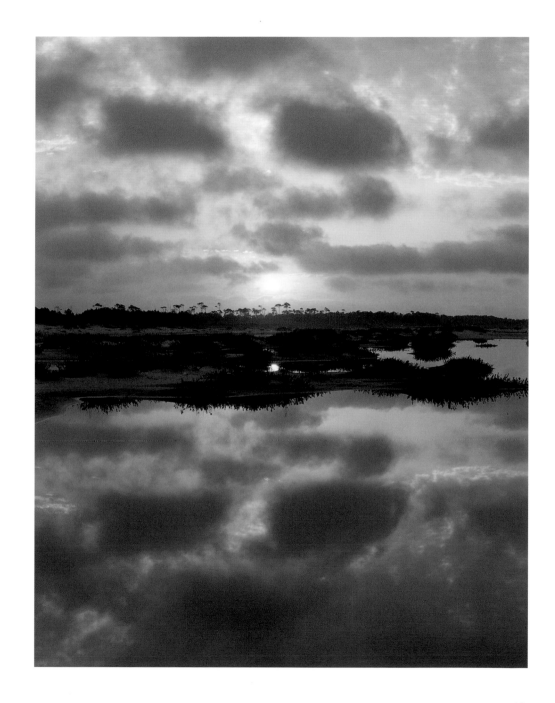

At many of the world's beaches, sands exhibit a remarkable musical gift. When the wind passes over them, sands can produce a variety of sounds, from the silky rustling and dog-like barking of the dunes on Kauai, Hawaii, to the eerie whining of the sandstone cliffs on the Isle of Eigg in the Hebrides. *The Arabian Nights* tells of the tinkling sands of the Mountain of the Bell on the Isthmus of Suez which, in a storm, bellow and groan like the bass notes on a pipe organ. No one really knows what produces these bizarre acoustic phenomena, although scientists have attributed them to everything from the mechanical friction of salt-coated sand grains to the percussive effect of tiny pockets of air released by shifting sands.

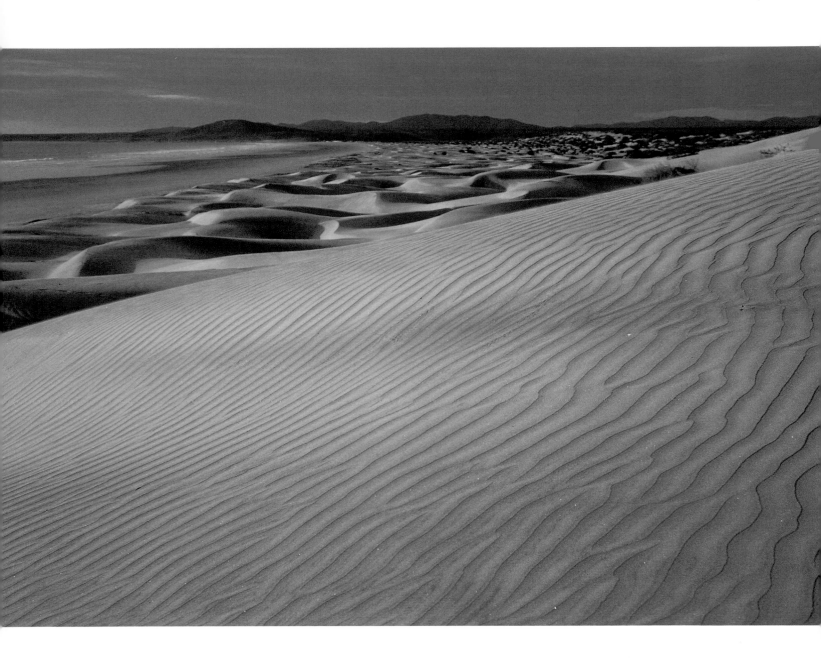

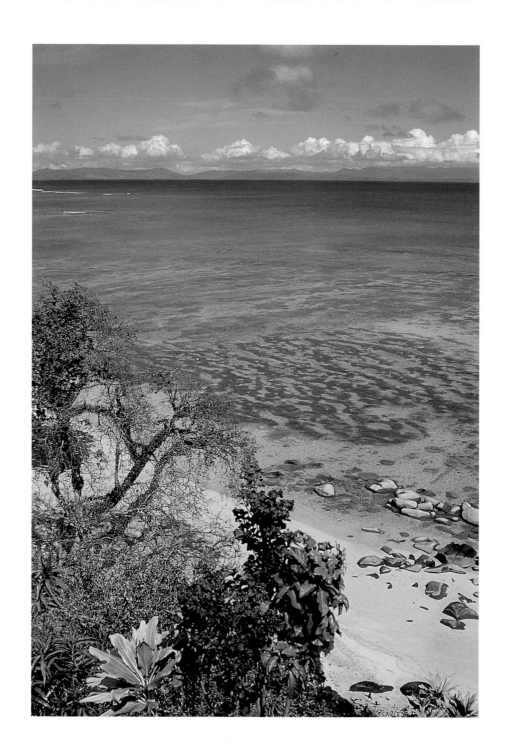

Below the surface of the water, the coral reef manifests an extraordinary complexity and biological diversity. Each species of coral polyp, the creature responsible for the submarine landscape, constructs its own distinctive habitation according to a blueprint to which it holds the exclusive patent. Built of calcium and carbonate ions extracted from the seawater, the skeletons that shelter the soft-bodied polyps take the shape of stars, pores, pillows, blobs, and asterisks. Dividing asexually, the individual polyps grow into colonies that cluster into shapes we recognize as plates, branches, tables, convoluted brains, staghorns, vases, and organ pipes. Calcareous algae, decomposed plant matter, and the shells of small animals supply the "cement" and filler that binds corals into the megastructures of coral reefs.

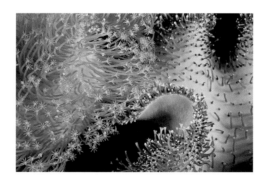

LEATHER CORAL | *Coral Sea, New Guinea*

SOUTH PACIFIC OCEAN | *Fiji*

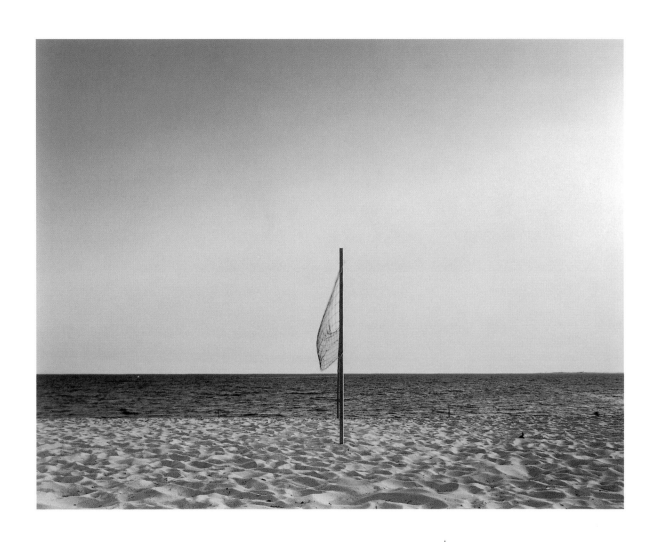

CAPE COD BAY | *Cape Cod, Massachusetts*

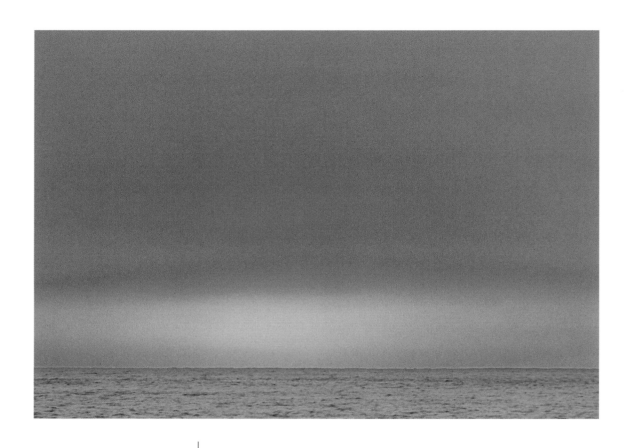

PACIFIC OCEAN | *Hawaii*

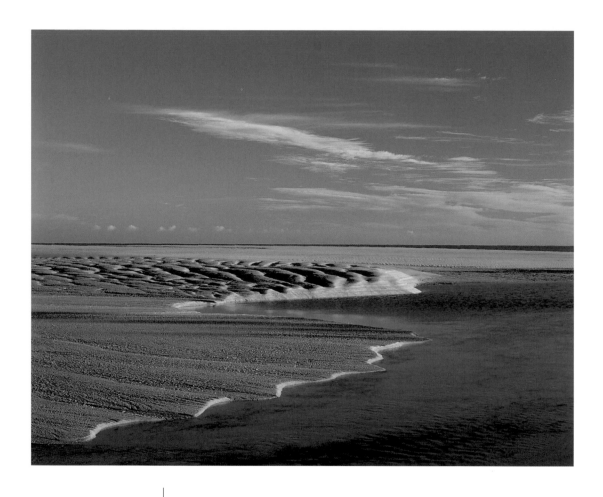

TASMAN SEA | *Tip of South Island, Able Tasman Park, New Zealand*

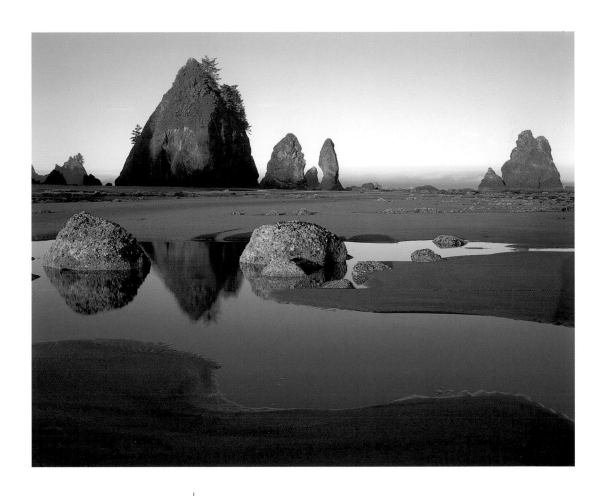

PACIFIC OCEAN | *Point of Arches, Washington*

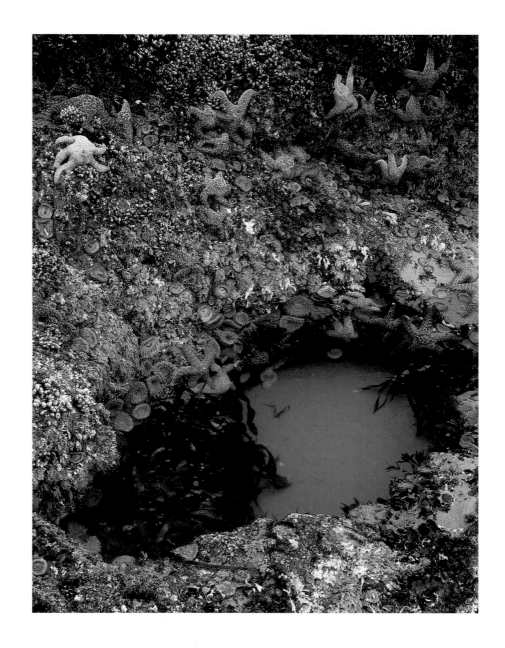

Nature's aquariums, tide pools form on rocky beaches wherever the outgoing tide is trapped in hollows or by natural dams. Alternately exposed and covered by the shifting tides, the midlittoral zone is defined by the presence of distinctive brown seaweeds—rockweeds and brown algae of the genus *Fucus*—and acorn barnacles along its outer margin. Slightly lower lie beds of mussels, and lower still live crabs, chitons, sea stars, and goose barnacles. Beneath loosely embedded rocks where they are protected from the surf, the sand, and desiccation, brittle sea stars and ribbon worms coexist with slippery, sticky blennies. "It is a fabulous place," wrote John Steinbeck in *Cannery Row,* describing the tide pools in Northern California. "When the tide is in, [it is] a wave-churned basin, creamy with foam, whipped by the combers that roll in from the whistling buoy on the reef . . . The sea is very clear and the bottom becomes fantastic with hurrying, fighting, feeding, and breeding animals."

TIDE POOL | *Bandon State Park, Oregon*

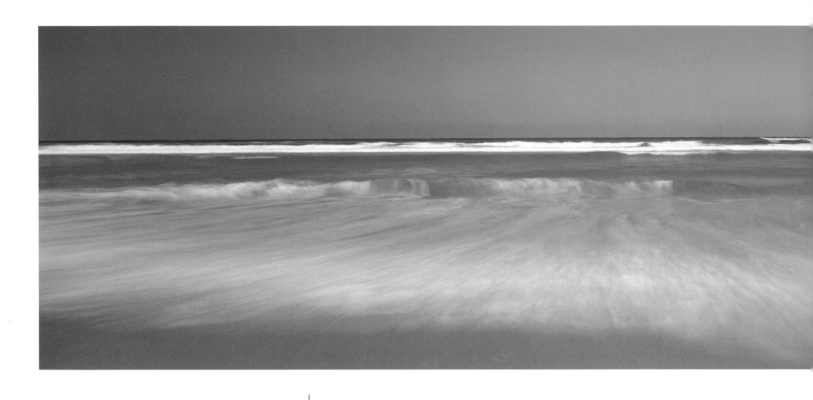

SOUTH PACIFIC OCEAN | *Fraser Island, Australia*

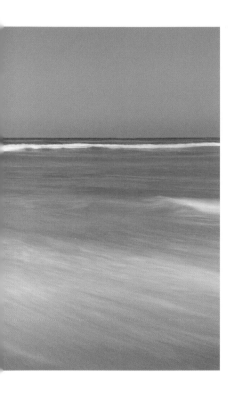

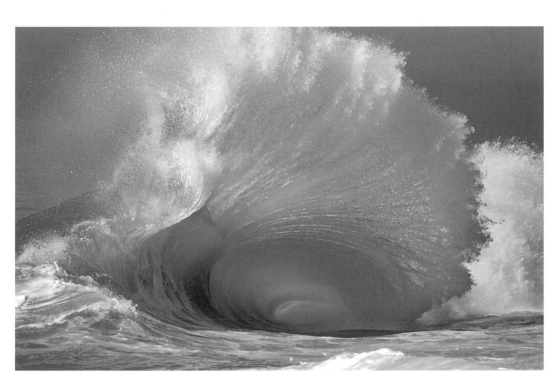

PACIFIC OCEAN | *Newport Beach, California*

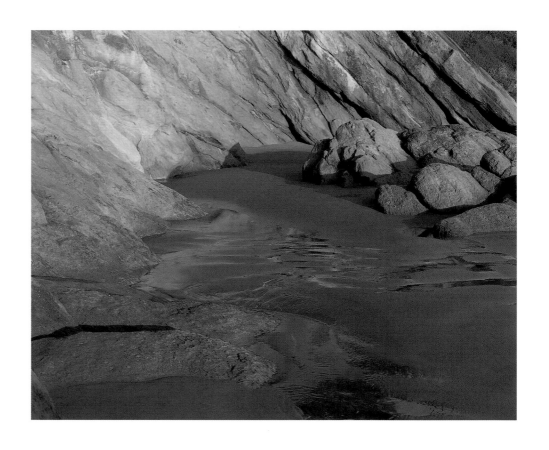

PACIFIC OCEAN | *Hug Point, Oregon*

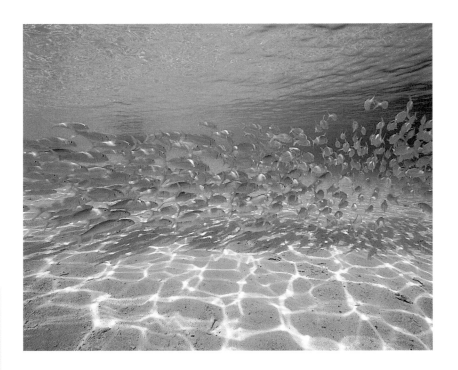

SOUTH CHINA SEA | *Sipadan, Malaysia*

CARDIGAN BAY | *Port Oer, Wales*

Estuarial beaches can present a particularly challenging obstacle to an advancing sea. When tides flow into estuaries they undergo dramatic transformations. Snagging against the shallow bottom, the rapid flow of water slows down, twisting and heaping up as it meets more resistance. Usually, the water level rises more rapidly than it can fall, and the flood, or incoming tide flows faster than the ebb, or outgoing tide. The most remarkable of these phenomena is the tidal bore, which occurs when a large portion of the flood tide enters a river mouth as a turbulent mass of water with an almost vertical wave front, followed by a series of choppy waves. Half-a-dozen or more famous tidal bores exist in the world, three in the British Isles alone on the Trent and Severn Rivers and in the Solway Firth. One of the most dramatic is at the estuary of the Xiang Jiang River in the Bay of Hangzhow, where the wall of tidal water reaches a height of about eleven feet and moves up the river at a speed of about twelve knots. The bore of the Amazon River travels upstream for some two hundred miles, a record distance among tidal bores, with the result that as many as five flood tides are moving upstream at the same time.

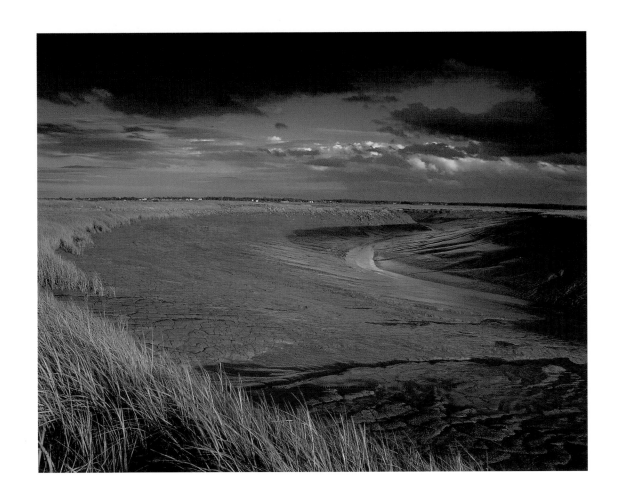

A healthful cocktail of chemicals, seawater was an important pharmacological agent in the medicinal practices of antiquity. Greek and Roman medical authorities, from Hippocrates to Galen, prescribed seawater diluted with honey or milk for ailments ranging from worms to yellow fever. While seamen throughout the ages drank seawater as an excellent purgative, professional European physicians largely ignored its healing properties well into the eighteenth century. Then, as part of a larger cultural revival of the classics, the medical books of the ancients gained new currency and a handful of progressive physicians began to lend credence to antique remedies. Foremost among them was Richard Frewin, a physician who in 1748 conducted a clinical trial in which he treated an enfeebled young aristocrat for three months, November through January, with daily sea baths and a dose of a quart of seawater. The resounding success of the treatment was publicized by another physician, Dr. Richard Russell, in a scholarly treatise entitled *A Dissertation on the Use of Seawater in the Diseases of the Glands, Particularly the Scurvy, Jaundice, King's Evil, Leprosy and the Glandular Consumption*. Russell agreed that by regulating glandular secretions, seawater baths and quaffs, supplemented with seaweed massage and hot seawater showers, purified the system, controlled toxins, and energized the organism. Converted to the saltwater cure, splenetics, gout-ridden bon vivants, consumptives, melancholics, and adolescent girls began to consume vast quantities of salt water, both at the beachside resorts of Southampton, Brighton, and Margate, and inland, purchasing bottled seawater at designated inns and markets.

HEALING MUD BATHS | *Vulcano, Italy*

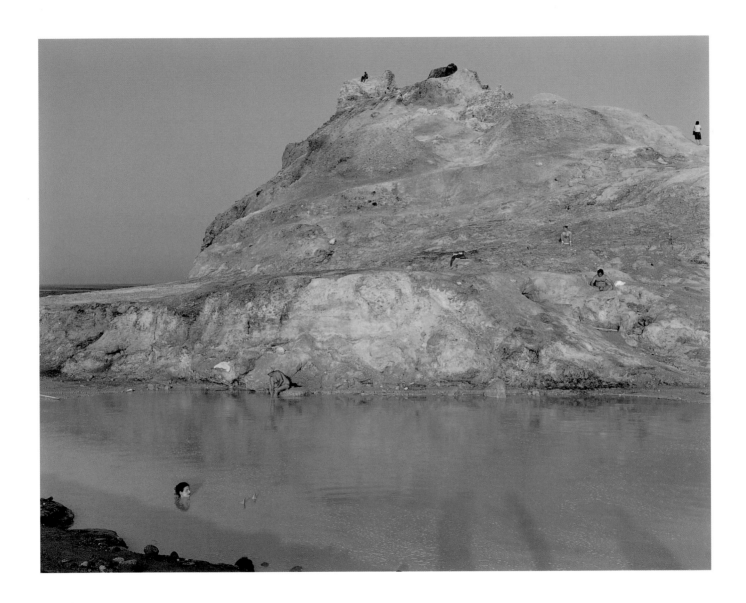

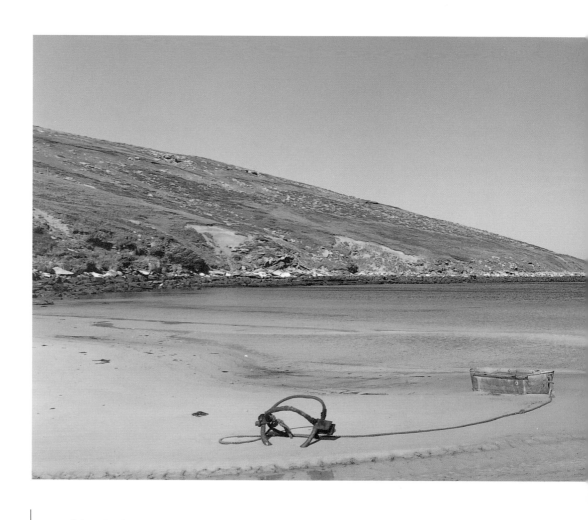

ATLANTIC OCEAN | *Falkland Islands*

68

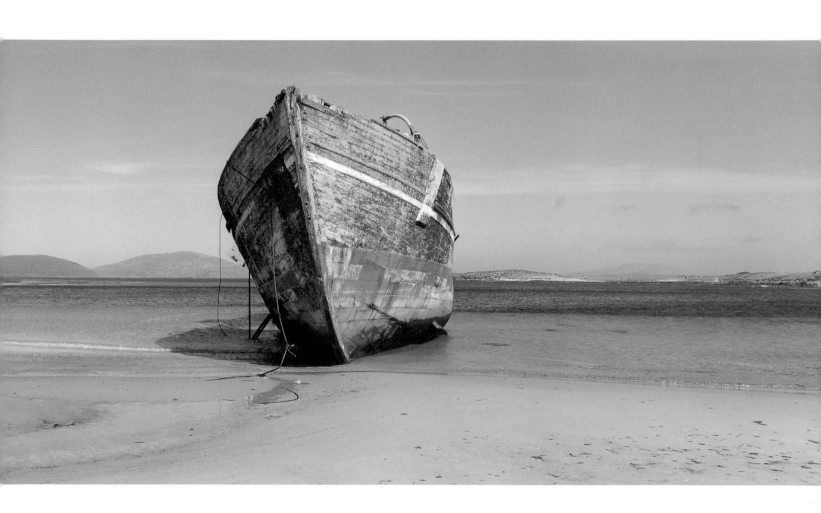

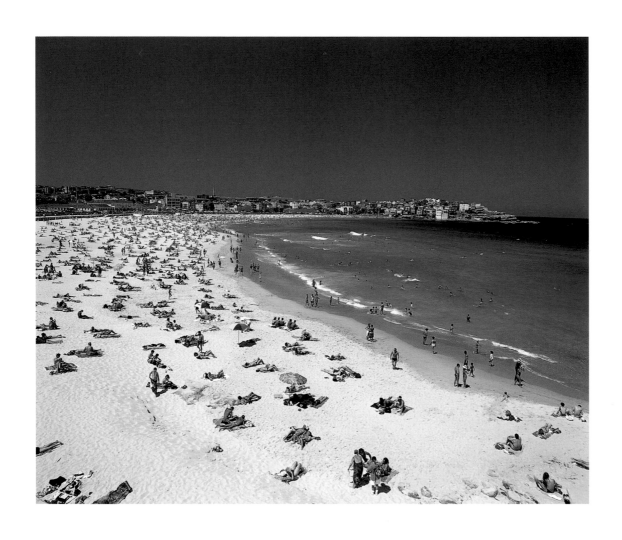

SOUTH PACIFIC OCEAN | *Bondi Beach, New South Wales, Australia*

With their love of the sea, the Romans invented the beach holiday. Passionate bathers, they constructed luxurious coastal retreats, public natatoria, and leisure outposts where both elite and commoners escaped from the heat and bustle of urban life. Rome's finest thinkers, writers, and statesmen—Cicero, Pliny the Younger, Seneca, Marcus Aurelius Antoninus, Pompey the Great, and Emperor Trajan—took frequent seaside vacations, which they structured on the formula of *otium cum dignitatae,* relaxation with dignity. These early prototypes of the working holiday involved a finely balanced regimen of meditation, physical exercise, intellectual stimulation, and sensual pleasure. The affluent commissioned elegant villas sited to frame beautiful views of the sea through lush plantings. They bathed in artificial bays, enclosed by massive constructions, that were filled with fresh seawater by each incoming tide. It was with particular reference to the architectural extravaganzas in the popular seaside resort of Baiae that the poet Horace wrote that rich men "contract for blocks of marble to be hewn, and unmindful of the grave, are rearing mansions and are all eagerness to thrust back the shores of the sea."

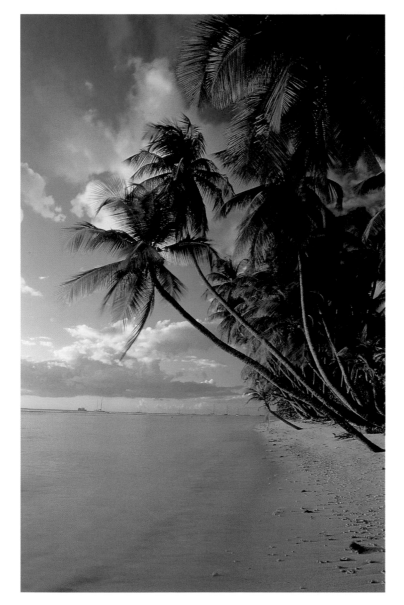

CARIBBEAN SEA | *Pigeon Point, Tobago*

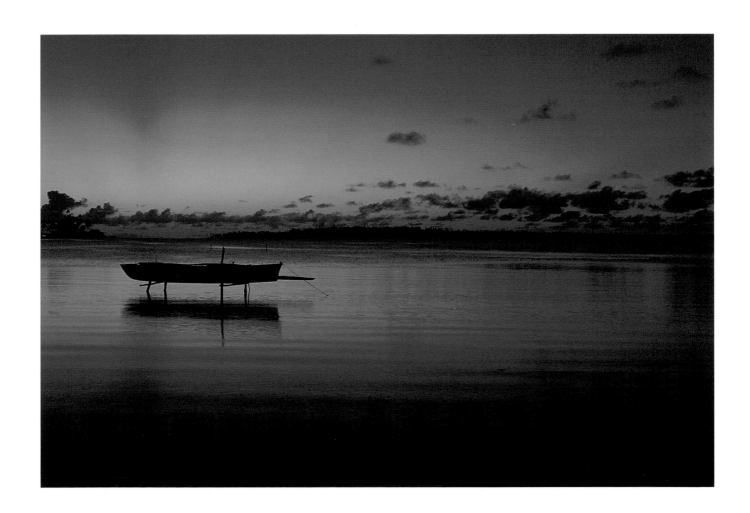

CORAL SEA | *Orpheus Island, Queensland, Australia*

SOUTH PACIFIC OCEAN | *Twelve Apostles, Victoria, Australia*

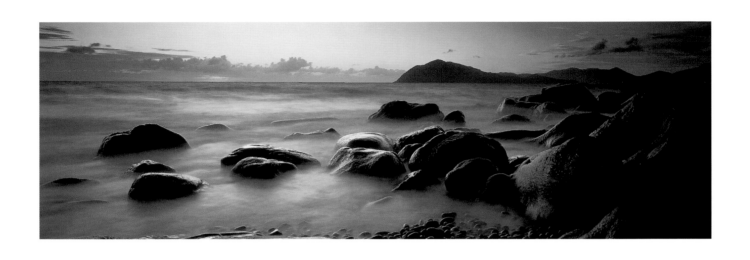

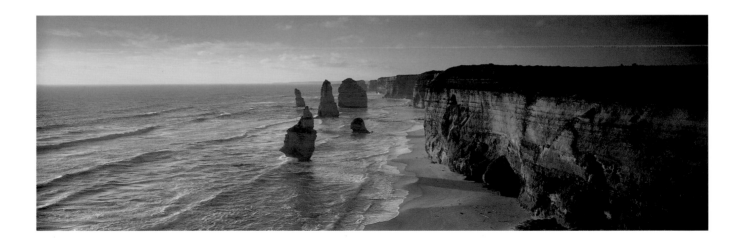

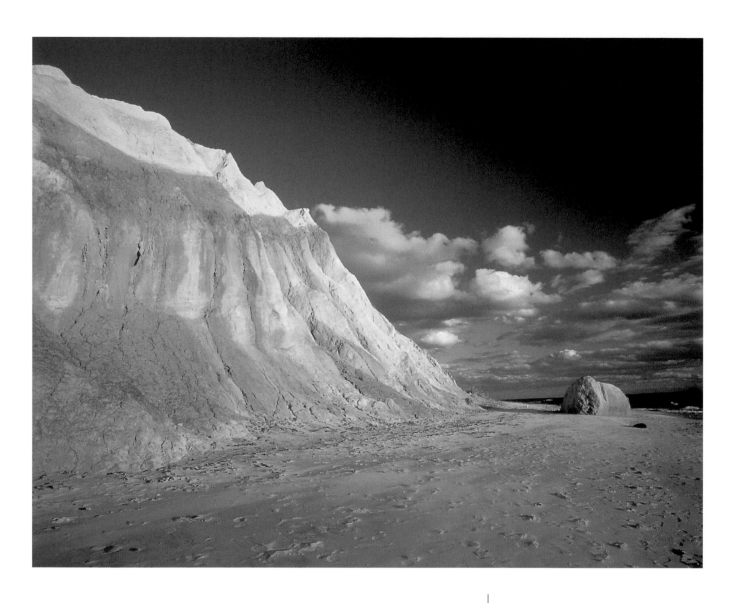

ATLANTIC OCEAN | *Gay Head Beach, Massachusetts*

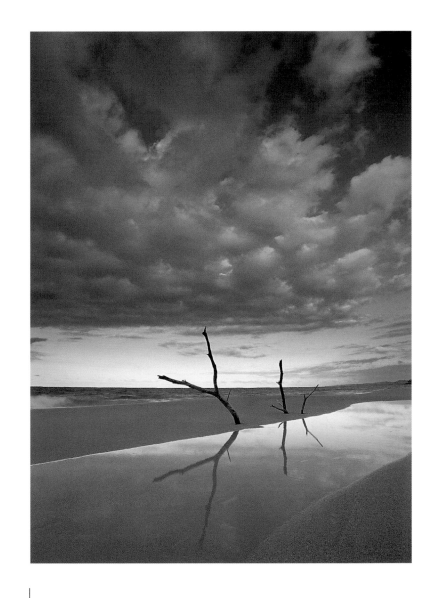

CARIBBEAN SEA | *Bocas del Toro Island, Panama*

Salinity is affected by evaporation and by dilution through rainfall and freshwater inflow. The saltiest waters are in the Red Sea and the Persian Gulf, where the hot sun and the intense heat of the atmosphere produce swift evaporation. By contrast, the freshest seawater is found in the Baltic and the Black Seas, whose waters are diluted by the influx of many large rivers. The extreme for salinity, however, is the Dead Sea, which has a concentration of salt so high that it is fatal to life. Any fish that make it down the River Jordan die as soon as they enter the waters of the Dead Sea. Now about a fourth of its original length and volume, this shrinking body of water is all that remains of a large inland sea that once filled the entire Jordan Valley. Situated 1,300 feet below the Mediterranean, it also lies farther below sea level than any other body of water in the world. Not only is it exposed to a burning, desiccating atmosphere, but because its waters are warmer that air temperature, the Dead Sea evaporates at an extraordinarily brisk rate. Clouds of vapor hover over its surface, and whatever swimmers venture into its mineral-rich waters float as though on an air mattress.

SALTON SEA | *California*

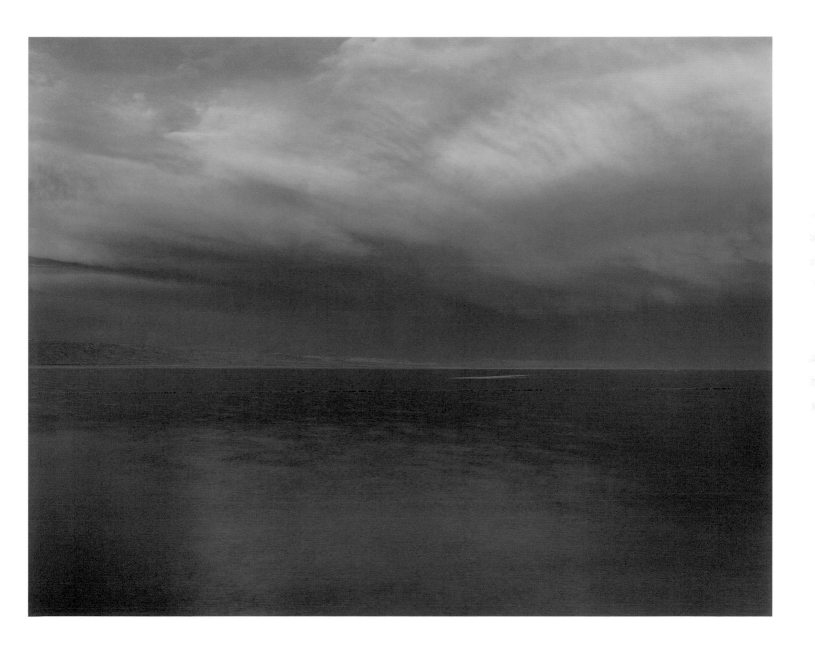

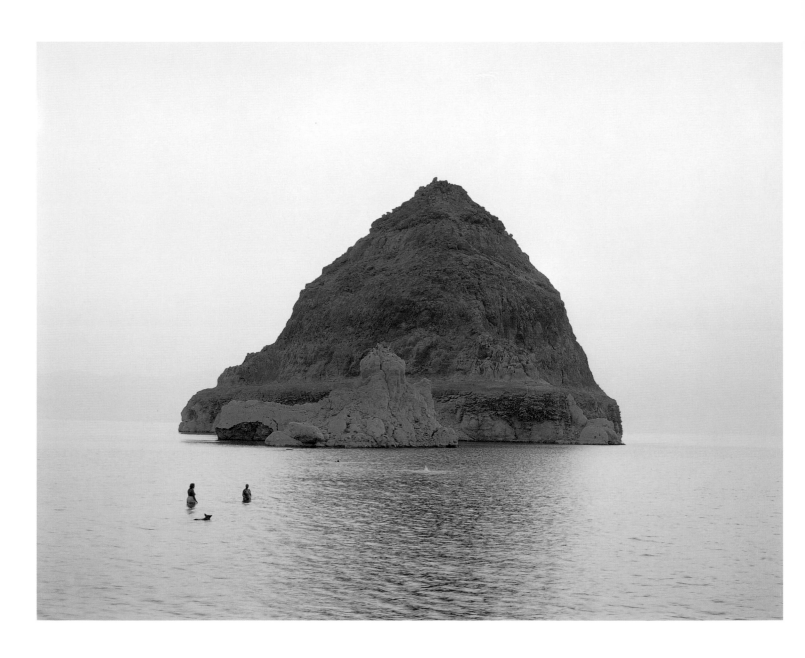

80

PYRAMID LAKE | *Nevada*

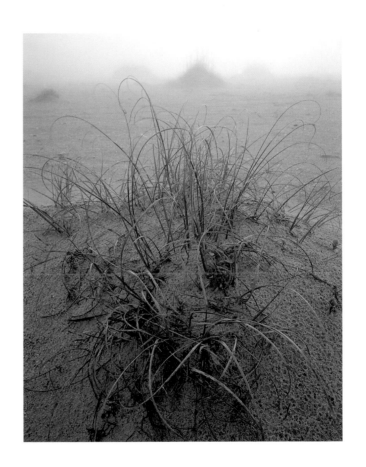

ATLANTIC OCEAN | *Cape Hatteras National Seashore, North Carolina*

The wind is constantly rearranging the look of the beach. A brisk breeze will cause the sea to surge and deposit pools high on the backshore, as in the flat barrier beaches along the Atlantic coast of the southern United States. A stiff wind will drive waves to carve out gullies on the beach face parallel to the ocean and fill them with water so they resemble long ponds. This often happens in the winter months along the beaches of Normandy, France. On the beaches of Cancun, and farther south along the Gulf of Mexico, wind will dimple the sand close to the waterline as it strips off the top, dry layer and gnaws at the dampness beneath. In the Pacific Northwest, the incoming tide is often accompanied by an onshore wind that keeps the sand in motion as a fine, stinging veil about a foot thick above the ground. When the wind dies down, the shore will lie smooth and soft once again, banked and swirled neatly around driftwood.

GULF OF MEXICO | *Gulf Islands National Seashore, Mississippi*

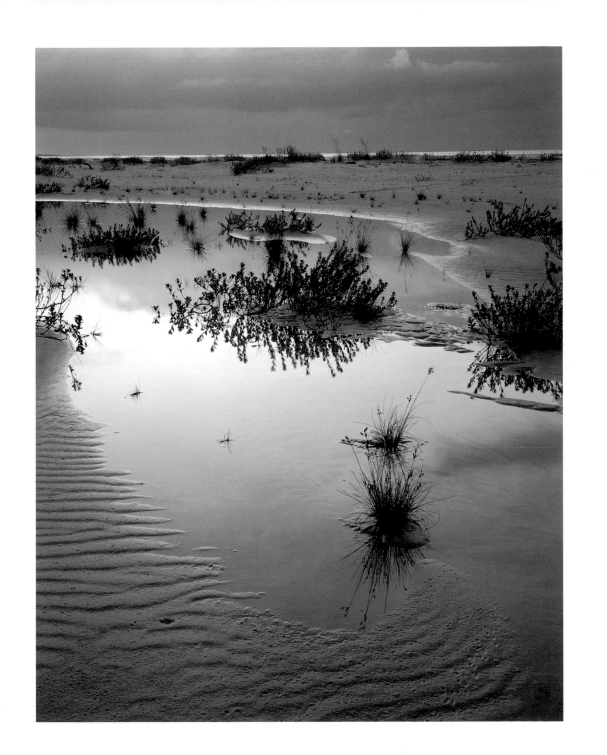

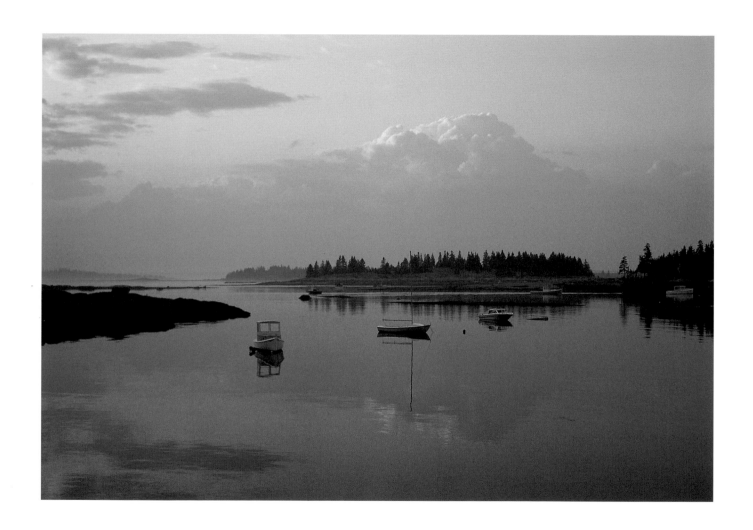

Before it became the preeminent site for an inexhaustible range of pleasurable pastimes, the beach was a workplace. Since time immemorial, fishermen have farmed the seashore for seaweeds, crustaceans, and edible shells and extracted salt from seawater in shallow holding pens that were filled with the rising tide, then sealed off until the water evaporated. Remains of salt works dating to Roman times can still be found in the saltwater marshes all along the Atlantic coast of France. For centuries, beach sands were hauled away for making lime, concrete, and glass, and the coast was mined for gold, diamonds, zircon, and oil. In modern times, both the automobile and the airplane were launched on beaches. The Wright brothers made their first flights at Kitty Hawk on the Outer Banks of North Carolina. Farther south, at Daytona Beach, Florida, early automobile models were tested on eighteen miles of hard-packed sand that would continue to be used as a stock car racetrack until 1959. Just a few miles south of Daytona, on the beach of Cape Canaveral, the first manned flights into space proved once again that the beach has always marked the threshold of human experience.

BLUE HILL BAY | *Deer Isle, Maine*

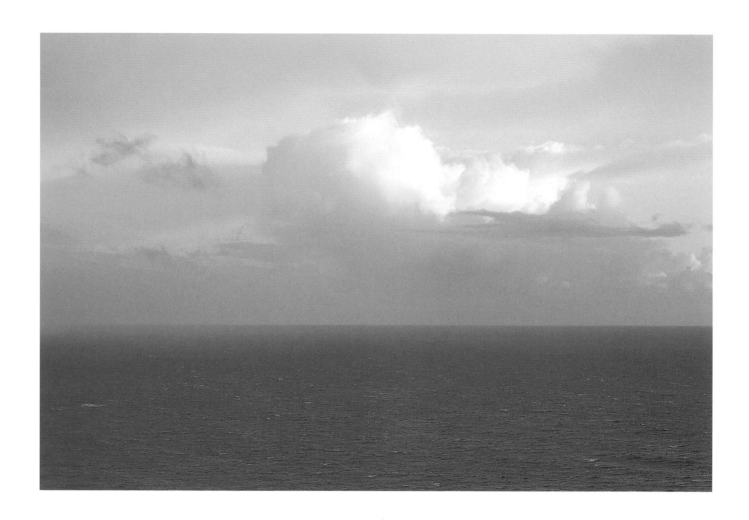

86

PACIFIC OCEAN | *Manzanita Beach, Oregon*

LONG ISLAND SOUND | *Bluff Point State Park, Connecticut*

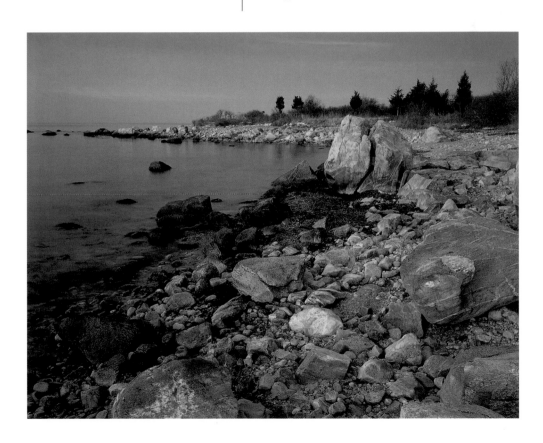

ENGLISH CHANNEL | *Durdle Door, Dorset, England*

Sea bathing as a medicinal treatment was invented by the British in the mid-seventeenth century, when a physician by the name of Robert Wittie began promoting seawater as a remedy for a variety of infirmities. Within fifty years, progressive British physicians were prescribing immersion in the winter waters of the North Sea and the English Channel for every ailment from melancholy to scrofula. Affluent invalids flocked to bathing facilities at Scarborough, Weymouth, Brighton, and Torquay for the saltwater cure. The bathing protocol, promoted as part of the most advanced medical treatment, was brutal. Every day for four to six weeks, patients boarded bathing machines—horse-drawn cabins on wheels—for a short ride into the sea, where a professional "dipper" repeatedly plunged them into the frigid water. The therapy acquired and retained social cachet when several generations of British royalty—from George III to Queen Victoria—embraced sea bathing, inspiring emulators on both sides of the English Channel. By the first quarter of the nineteenth century, seaside bathing facilities based on the British model could be found throughout the British Isles, on the western coast of France, and in the Netherlands and Germany.

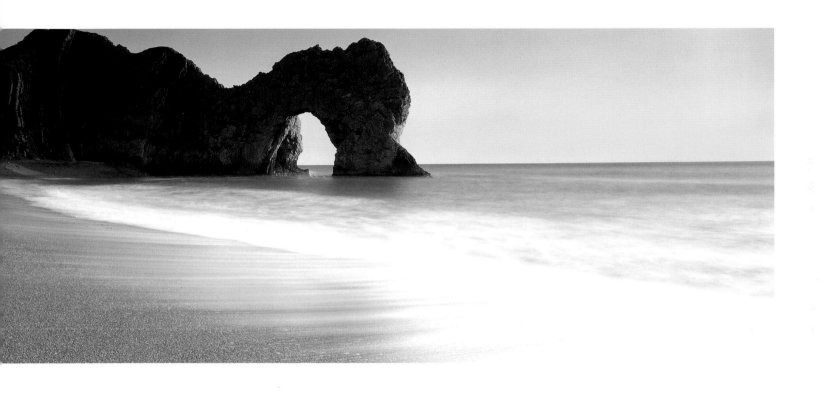

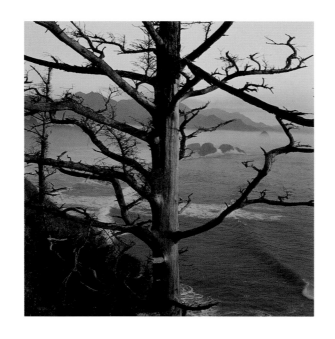

PACIFIC OCEAN | *Ecola State Park, Oregon*

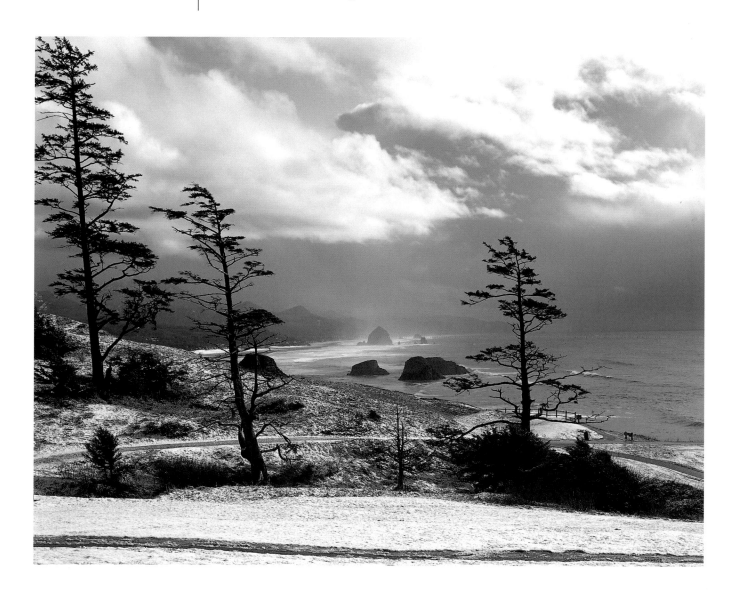

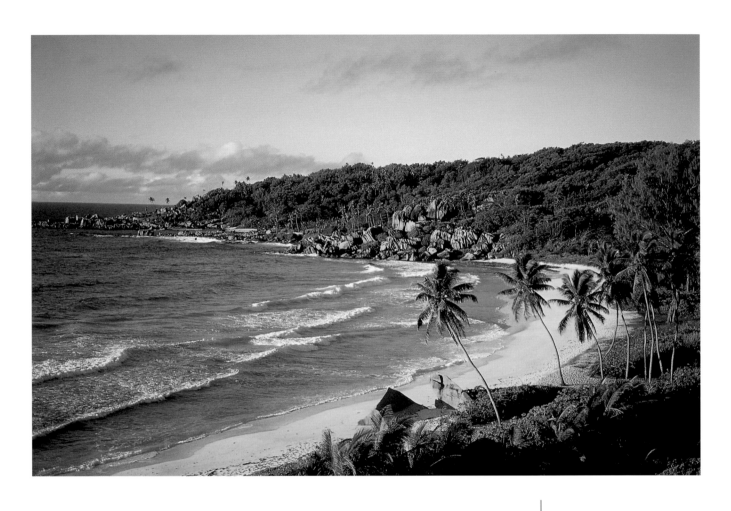

INDIAN OCEAN | *Grand Anse, Seychelles*

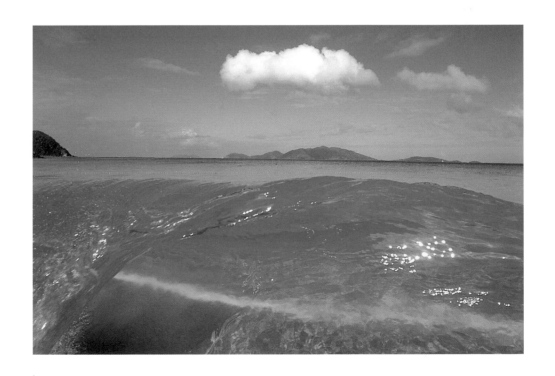

ATLANTIC OCEAN | *Tortola, British Virgin Islands*

Seen from above, coral reefs are the jewels of the sea, spots of color that stand out in the monotonous blue of tropical waters. Composed of the skeletons of minute organisms, they are the largest structures on earth made by living creatures. Coral reefs grow along the continental shelves of tropical and subtropical waters or on the shores of volcanic islands in warm seas. Charles Darwin identified three main types: the barrier reef, a long, massive, pointed construction with spurs facing into the oncoming swells; the atoll, ring-like in form and enclosing a lagoon; and the fringing reef, which grows outward from an island coast. Covered with pristine, organic sands, and a scattering of palm trees and grasses, coral islands are flat, ecologically understated environments. Writing in *In the South Seas,* Robert Louis Stevenson described a typical atoll as "rising at its highest point to less than the stature of a man—man himself, the rat, and the land crab, [being] its chief inhabitants."

CORAL SEA | *Langford Reef, Whitsunday Island, Australia*

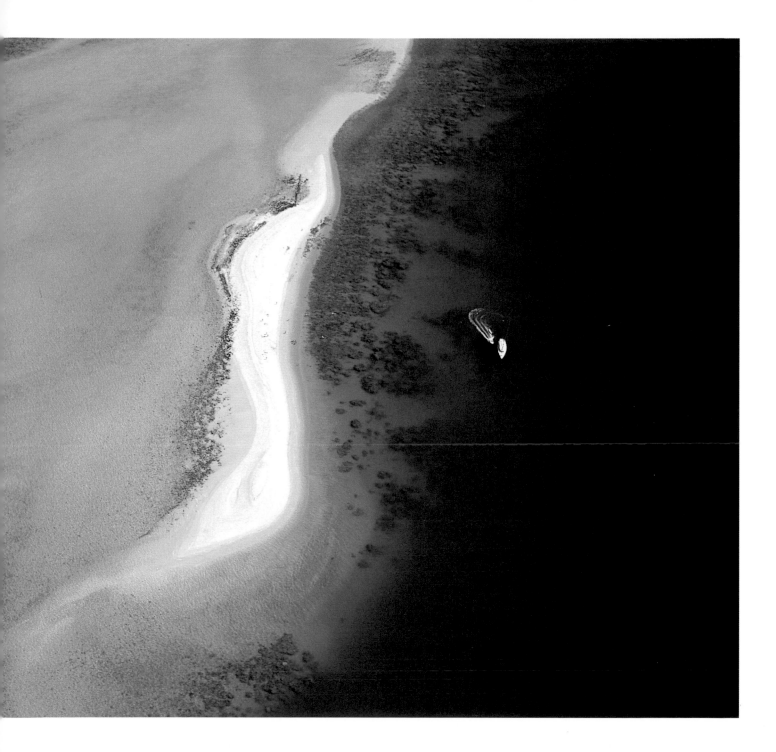

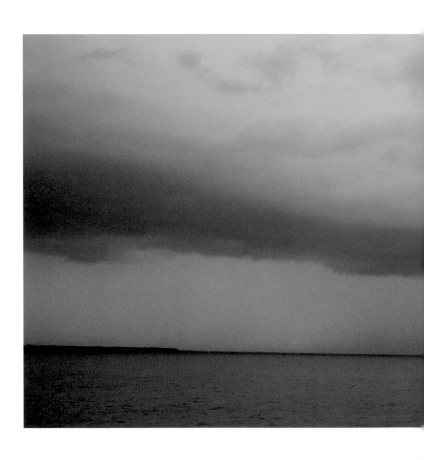

CARIBBEAN SEA | *Dominican Republic*

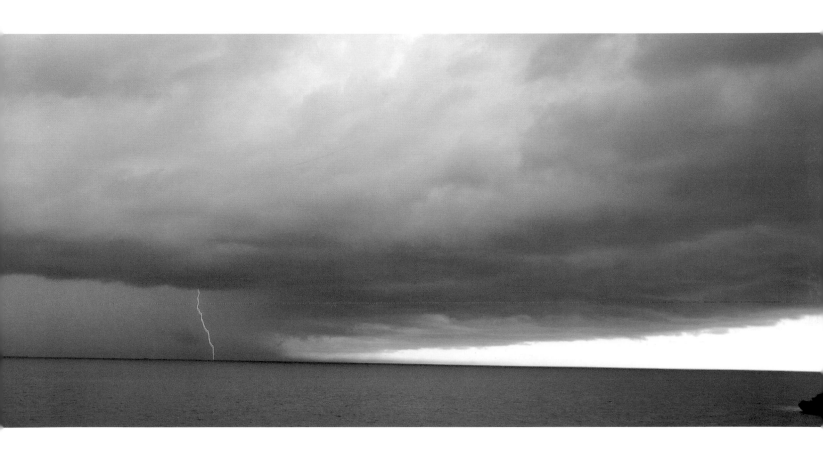

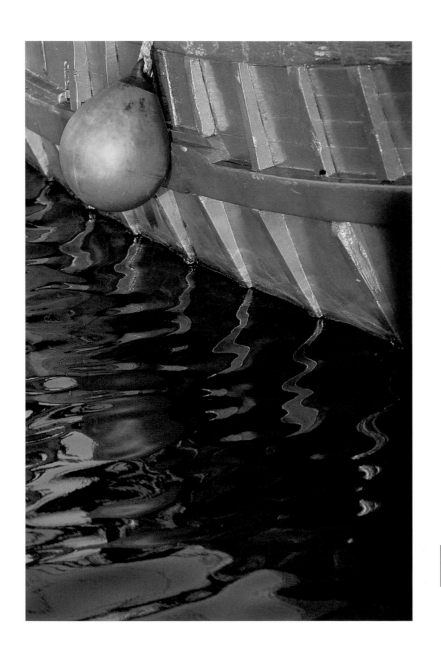

MENEMSHA HARBOR
Martha's Vineyard, Massachusetts

GREEN TURTLE | *Sangalakki Island, Indonesia*

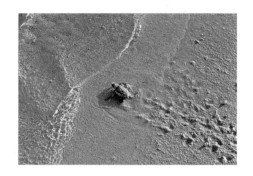

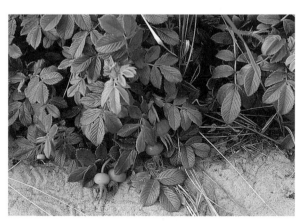

WILD ROSE | *Nantucket Island, Massachusetts*

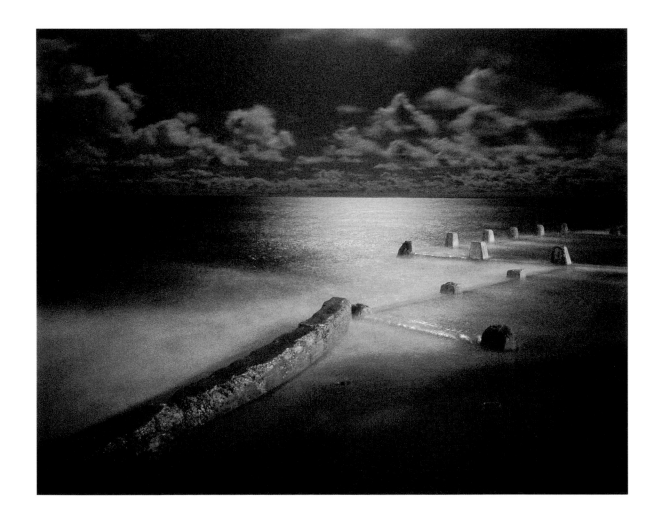

The surf is a capricious architect. Day in and day out, it cuts into the shore, rearranging sediment, chiseling cliff faces, undermining banks until they crumble into the waves in heaps of gravel that are flung back against the shore as fresh ammunition. With time, the land retreats—perhaps only a few inches, perhaps several feet. Millennia pass, and the margins of the continents are redrawn so drastically that no trace remains of once prominent geological features. Archeologists have found evidence of dramatic changes to the coastline, especially along the Mediterranean, whose ancient shoreline is estimated to have been about sixteen feet lower than it is today. The ancient city of Ephesus, in Turkey, was linked to its harbor by a colonnaded, marble road that now ends in a pile of sediment and rock a mile from the sea. Remains of sunken cities, such as the Minoan-Egyptian port of Pharos, the Phoenician port of Tyre, the Carthaginian ports of North Africa, and the Roman constructions along Italy's Amalfi coast and in the Bay of Naples, have been discovered in coastal waters. Swimmers and scuba divers report sighting fragments of quays, breakwaters, bollards, grottos, and beautiful mosaics beneath the waters off the Sorrentine peninsula and Capri. In other instances, sedimentation has gradually eliminated many beaches of antiquity, such as that belonging to Troy. In Achilles' time, the city used to overlook a large arm of the sea. Now it stands far from shore.

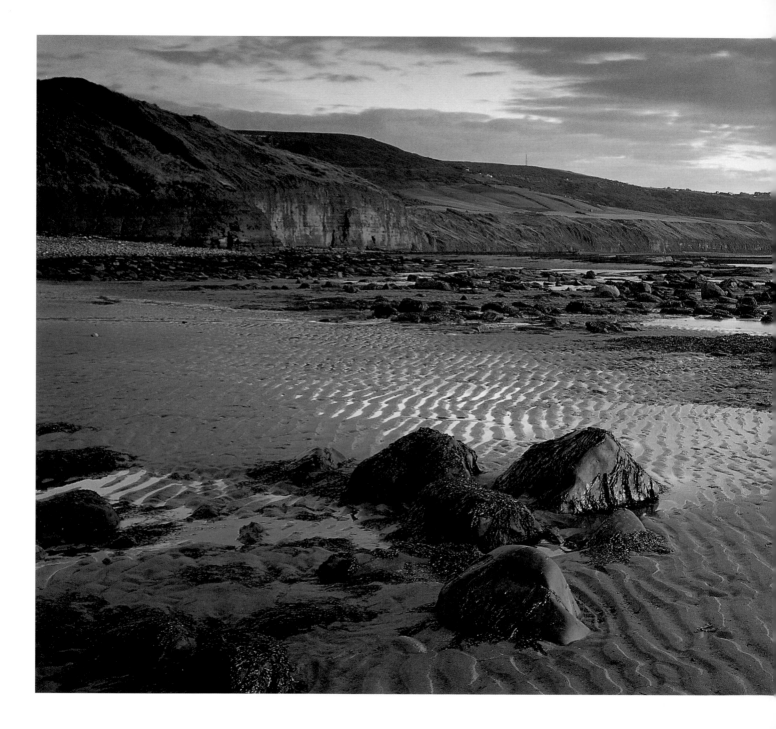

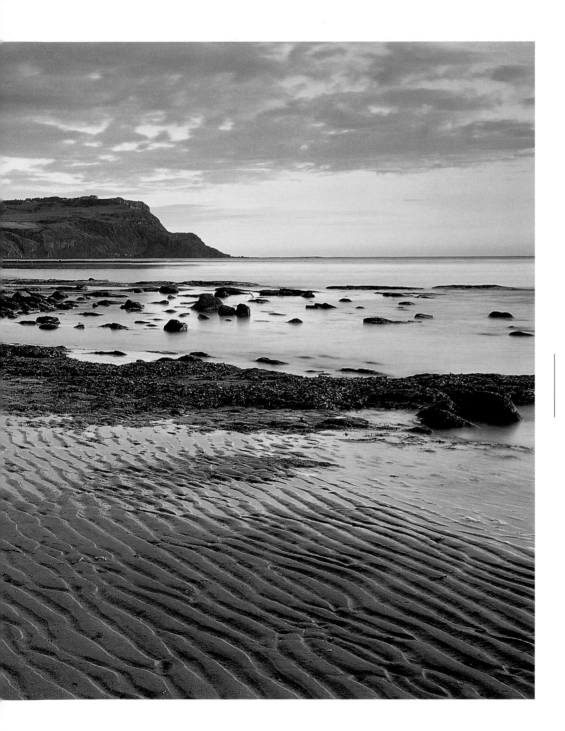

NORTH SEA
North Yorkshire Coast,
England

CARIBBEAN OCEAN | *Cancún, Mexico*

PACIFIC OCEAN | *Volcanoes National Park, Hawaii*

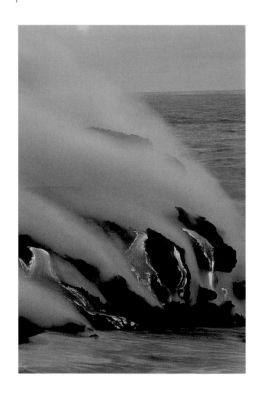

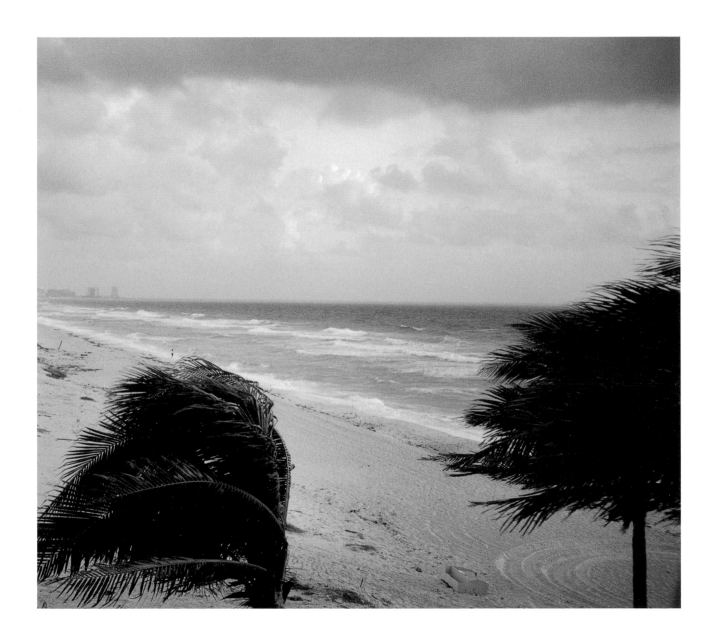

The point at which a wave finally expires on the beach is marked by a fragile curve of sand grains the water pushed up the slanting shore, to be erased by the next wave. Some of the water seeps into the beach; the rest runs back into the sea. This final retreat takes several forms. On a dry sandy beach, the sinking water leaves tiny airholes or hollow hillocks where it has displaced air. On a sloping sandy beach, the retreating wave scores the sand with a diamond pattern. At low tide, the saturated sand is drained through rivulets of water that create a miniature version of the arms of a river's delta. On a particularly calm day, with slow waves licking the shore at low tide, the sand forms ridges and troughs parallel to the waves.

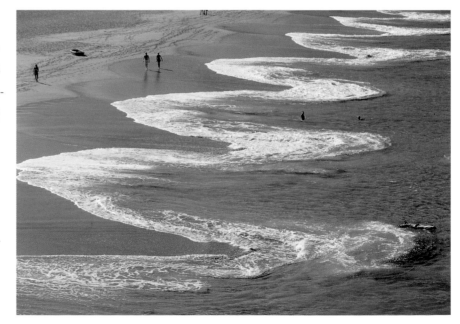

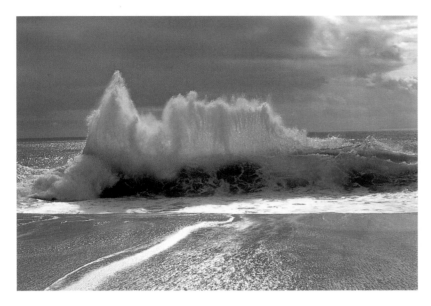

For all their infinite variety, wind waves breaking on the beach are of two basic types: constructive, formed close to shore, and destructive, born far out at sea. To tell the difference, observe their telltale shape as they approach the beach. Constructive waves appear on the horizon as steep, orderly, whitecaps. Destructive waves are a tumble of peaks, hollows, and spray. As constructive waves near the shore, the whitecaps spill down their fronts, bubbling and foaming until they exhaust most of their energy in a final prolonged and deliberate push to the beach. Here the breakers tamely race up the sandy slope, pushing ahead of them a light crown of scum the color of singed milk. This is the *swash,* a frothy blend of water, air, and sand that slowly dissolves on the beach face. Bit by bit, constructive waves deposit sand, building up the shore face in subtle increments. By contrast, a destructive, or storm, wave reaches the shore as a violent assault, hacking at the beach face, moving big chunks of sand and rock, and depositing often massive debris at its outmost limit.

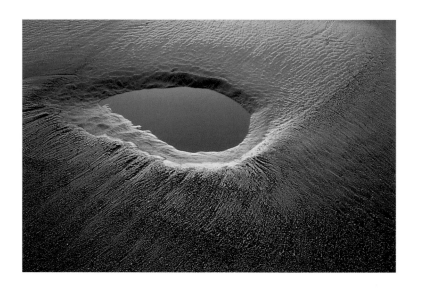

TIDE POOL | *Olympic Peninsula, Washington*

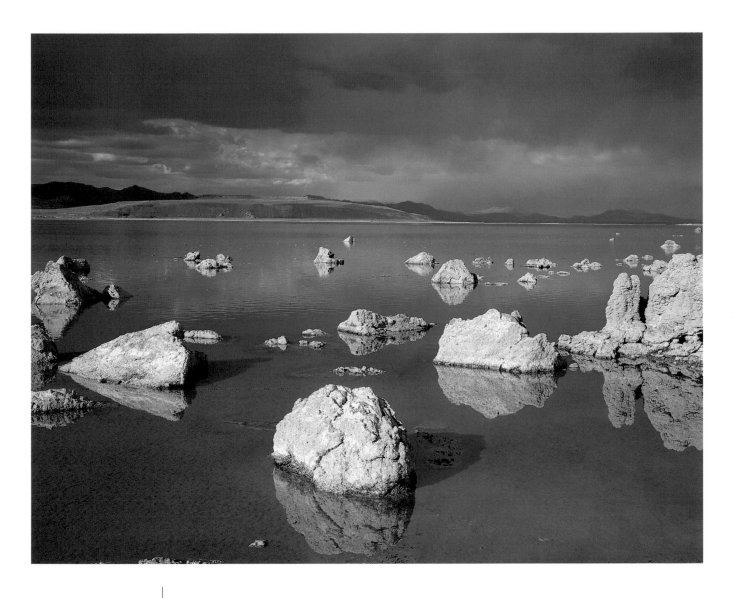

MONO LAKE | *California*

The destructive power of storm waves is staggering. In a single day, a winter storm can unleash as much energy as two dozen hydrogen bombs, completely reshaping a beach in the space of a few hours. Sand is stripped from the beach face and hurled into the back shore, exposing the dunes to direct frontal assault. Waves hack into the dunes and drag sand far into the water, laying down layer upon layer of sediment, and extending the shore face seaward. Stripped down to cobble and gravel, the beach face narrows and steepens. Now and then, a particularly potent wave washes over the wall of dunes, leaving some of its water behind and, in its retreat seaward, cutting an overwash channel through the dune ridge. When assaulting cliffs and escarpments, storm waves cut into overhanging masses of earth until they crumble into the water below. There, subjected to the action of fresh waves, they are broken down into shingle and gravel, to be flung back against the eroding cliffs. The land shrinks by anywhere from a few inches to several feet, depending on the severity of the storm. The same processes are repeated seasonally as winter storms dramatically reduce the shore face and strip it bare of its layers of sand.

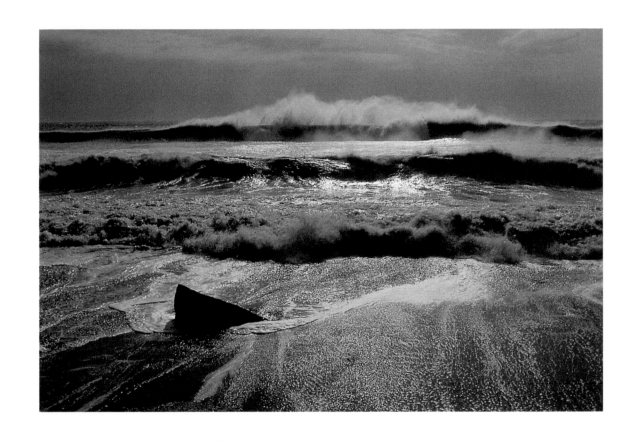

ATLANTIC OCEAN | *Lucy Vincent Beach, Massachusetts*

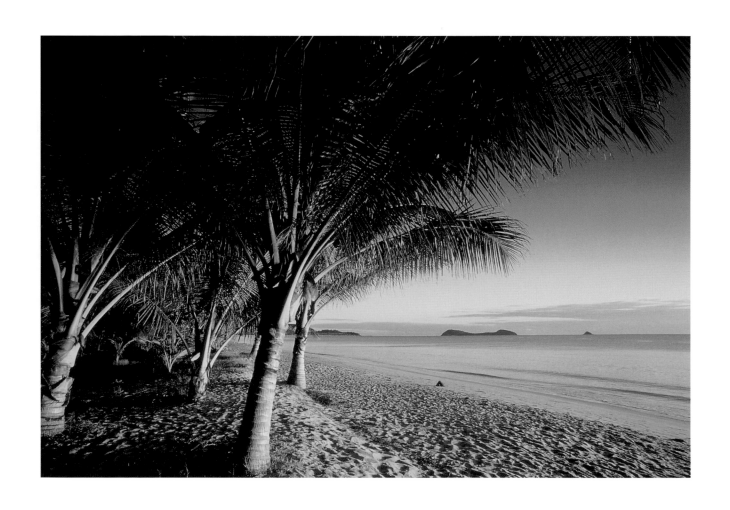

SOUTH PACIFIC OCEAN | *Palm Cove, Queensland, Australia*

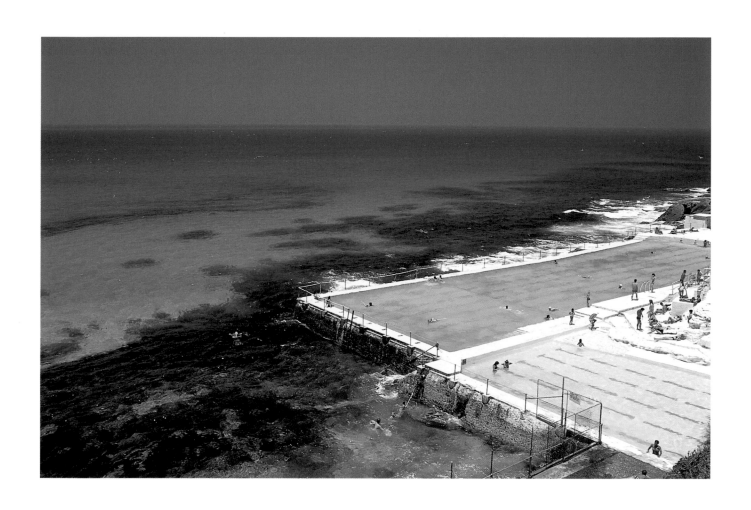

TASMAN SEA | *Bondi Beach, Australia*

113

VINEYARD SOUND | *Makonikey Beach, Massachusetts*

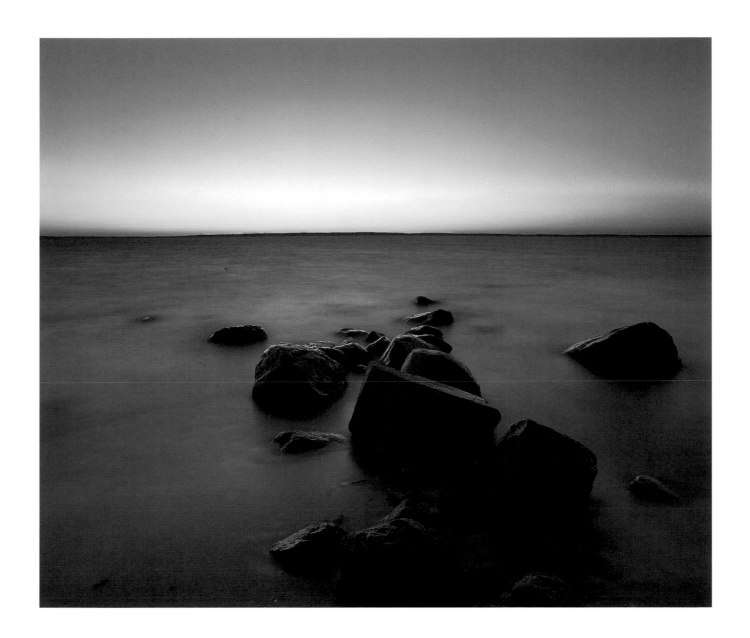

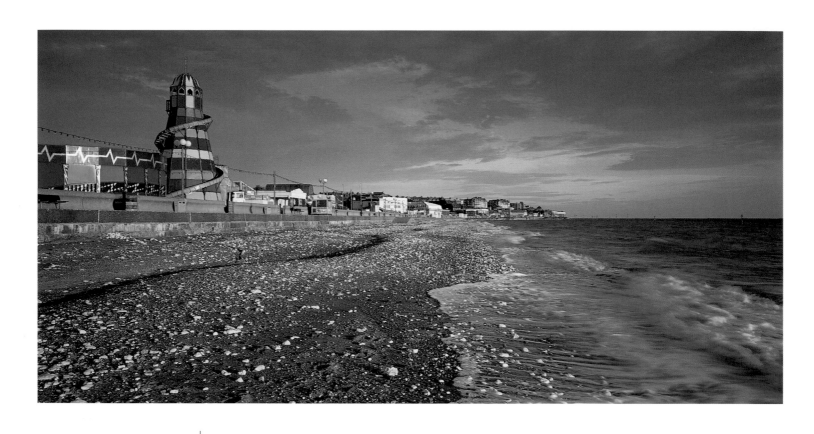

NORTH SEA | *Norfolk, England*

ATLANTIC OCEAN | *Balston Beach, Cape Cod, Massachusetts*

As a therapeutic agent, the sun has been the most recent addition to the medicinal arsenal of the beach. During the eighteenth and nineteenth centuries, patients sought out the seashore predominantly for the curative powers of its water and air, which is why they gravitated to northern beaches during the winter months. Only after World War I did Europeans discover the healing properties of the sun, and they shifted their beach holidays to the summer months in subtropical and tropical locales to take advantage of this new restorative. In part, this revolution in attitudes was cosmetically generated. In the nineteenth century, sunburned skin was the attribute of people who had to work for a living outdoors. By the early twentieth century, industrialization had shifted large segments of the working population indoors, so that a pallor replaced the tan as a marker of labor. Philosophers, writers, and artists such as Friedrich Nietzsche, Stephen Spender, and Paul Gauguin also played their part in popularizing the sun by extolling its energizing and life-giving properties.

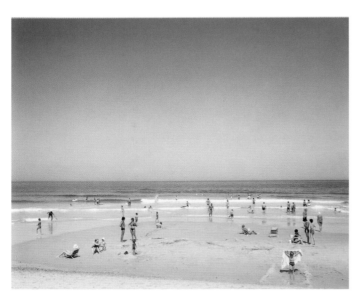

In the aftermath of the Great War, millions of soldiers who had fought in the mud and mire of trenches dreamed of escaping to tropical islands where they could safely expose themselves to the sun and heal their wounded bodies and minds. As soon as peace arrived, they followed a fashionable contingent of artists, aristocrats, and writers to the French Riviera, the Caribbean, and the South Pacific, cultivating perfect tans in imitation of the look canonized by trendsetting Coco Chanel.

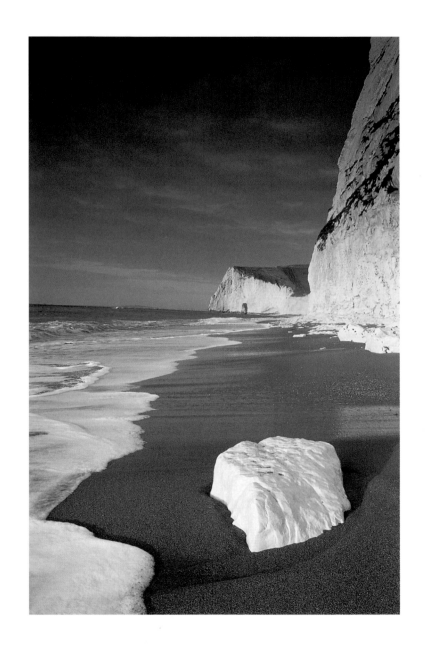

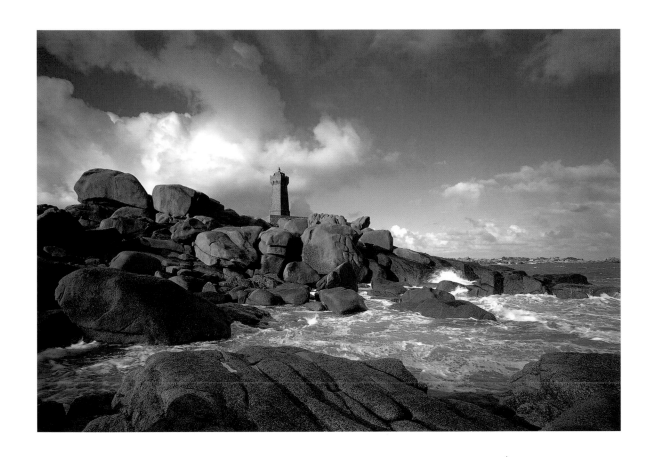

ENGLISH CHANNEL | *Brittany, France*

ENGLISH CHANNEL | *Bat's Head, Dorset, England*

If all the salt found in the earth's seas were extracted and gathered in one place, it would cover the United States with a mountain 4,500 feet high. While common to all the seawaters of the world, salt is not uniformly distributed. The salinity of seawater can differ from one location to another, or in different currents. It changes with depth at any one location, and the water at the poles is more saline than it is at the equator. Seawater containing more salt is heavier and less mobile than water that is less saline. Salt is thus an important indicator that tells oceanographers where currents, like the Gulf Stream, are flowing, because the sea is not well blended. Each current keeps its integrity for thousands of miles, maintaining its temperature and salinity until it loses itself in shallow seas. Cold, salty water tends to sink, while warm salty water and fresh water from rivers floats to the top. Salinity differences between one part of the ocean and another contribute to differences in density that, in turn, affect the circulation of the water and give rise to currents, both the horizontal ones in the depths of the sea, and the vertical ones that well up from the oceanic abyss and along the continental shelf.

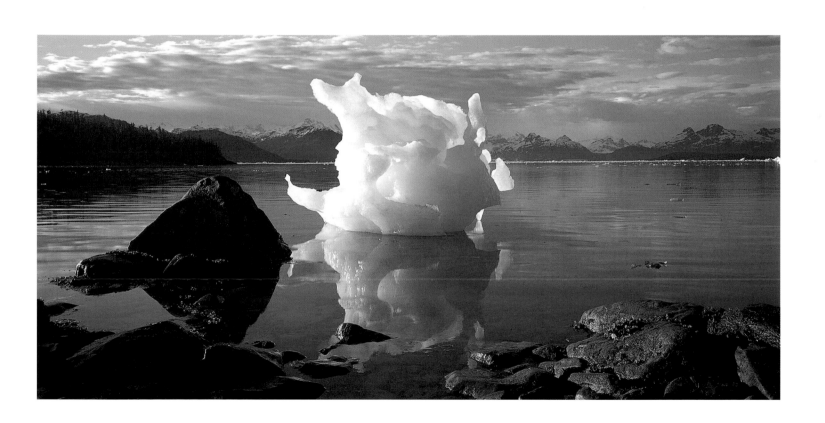

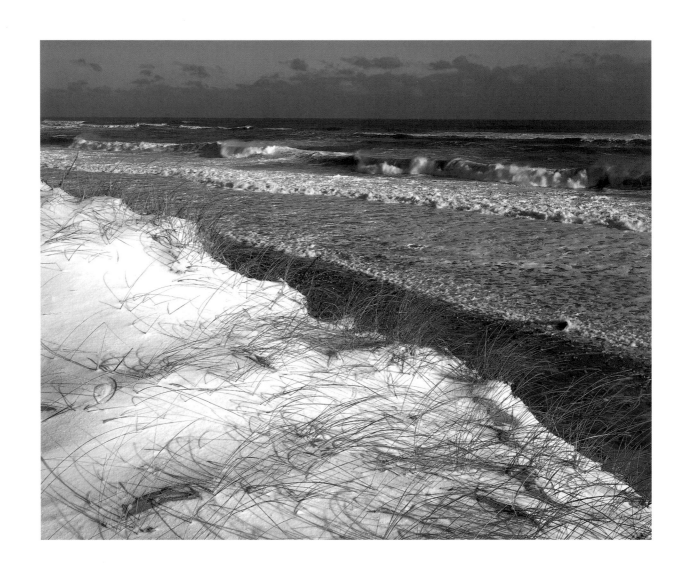

ATLANTIC OCEAN | *Cape Cod, Massachusetts*

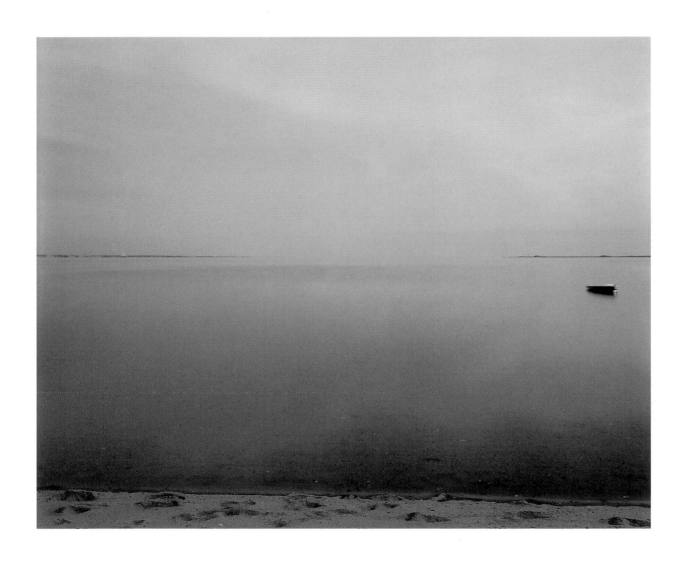

CAPE COD BAY | *Cape Cod, Massachusetts*

Thousands of miles of barrier beaches run along the east coast of the United States, southward from New York and then westward along the Gulf of Mexico. These fascinating structures of loose, unconsolidated sediment function as the mainland's first line of defense against the sea. Broad and heaped up with dunes, they either sit directly on the mainland, or they are on islands separated from the mainland by shallow bays many miles wide. Barrier island beaches began many thousands of years ago as natural dikes along the edge of the continental shelf where it drops off to the oceanic abyss. Between eighteen and six thousand years ago, when the glaciers began to melt, the sea rose as much as four hundred feet. It flooded the continental slope, filled up the river valleys, carved ridges into the land that would become headlands, and worked its way into the coastal forests. The rising waves pushed masses of soil, mud, rocks, trees, and sand as they advanced, heaping this detritus up along the shoreline wherever they ran out of energy. The wind shaped these pliant heaps into ridges and nudged them into parallel lines along the newly defined shore. As the water level rose farther, the sea broke through the ridges and flooded the mainly flat land behind them. The ridges—some no wider than a few yards, others a mile across and several miles long—were surrounded by water and became the first barrier islands.

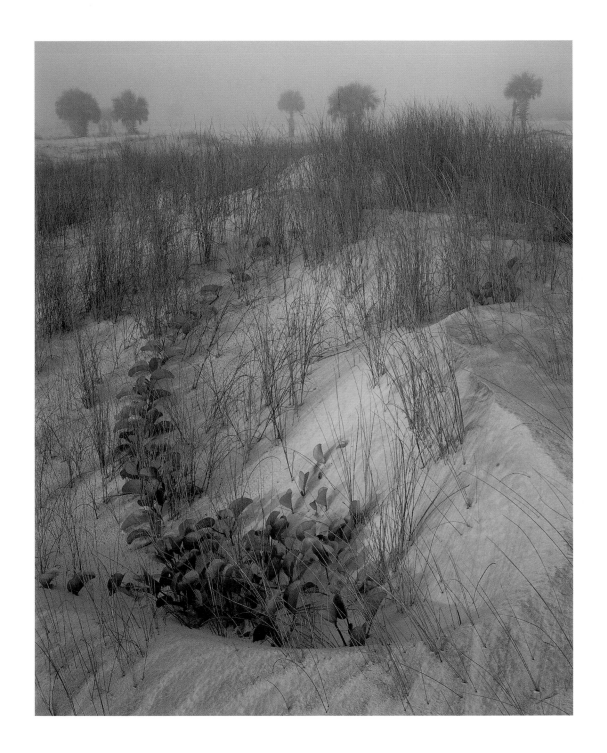

Sediment deposited on the beach face is subjected to a continuous sorting process as the material from which the beach is composed changes, the force of waves fluctuates according to season and weather, and the topography alters under the combined influences of erosion, augmentation, and climate. During winter storms, beach sediment undergoes the most intense resorting. On beaches composed of a mix of sand, gravel, and cobble, the larger sediment is deposited farthest up on the beach, moved there by high-energy breakers that scour away any sand and pile it well below the surf line. In winter, strong winds and tides drag vast amounts of sand into the sea, baring underlying cobbles. The exposed gravel, pebbles, and rock, far more resistant to the force of waves, are not carried away. Rather, they rearrange themselves when battered by a heavy sea to present a much steeper slope than a beach composed of sand. While in general a sandy beach has a slope of between one to five degrees, a pebble beach tilts at an angle of seventeen degrees, and a beach of coarse cobble will rise at an angle of twenty-four degrees. Cobble beaches are rough, violent places with constantly rolling and tumbling stones that have a rich range of textures and colors.

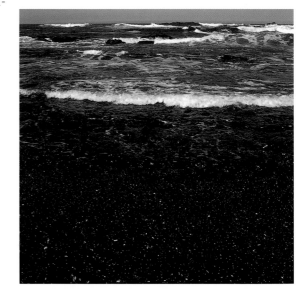

PACIFIC OCEAN | *Black Rock Beach, Oregon*

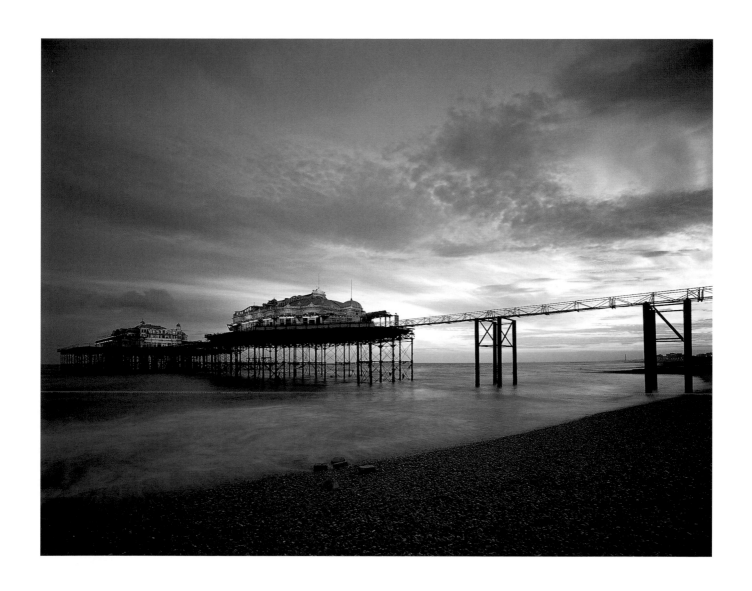

ENGLISH CHANNEL | *Brighton, England*

127

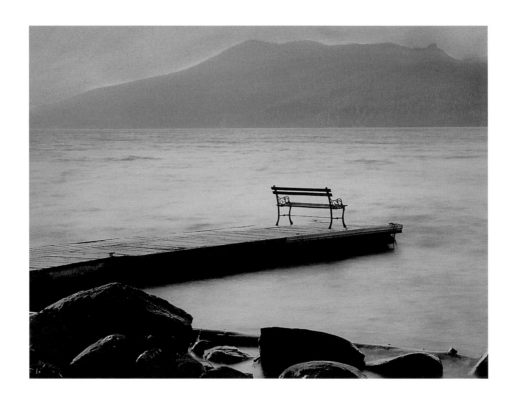

In The Spirit of the Sea

There are many places to experience the sublime interface where land meets water. Most people agree the beach is a place to meditate, to rejuvenate, and oftentimes, to just relax in an inspiring, therapeutic, and visually alluring environment. Depending upon personal tastes and preferences, each of us expects something a little different in our beach experience, but there are some qualities that we tend to hold in high esteem when we look for a vacation outpost near the sea: serenity, spectacular vistas, architecture that is harmonious with life on the shore, and pristine water and sand. Regretfully, the-beach-as-paradise has become an endangered territory, and knowing where to find a slice of coastal Eden has become an increasing challenge for those of us who are in search of the "five-starfish beach."

With these criteria in mind, we herewith offer our recommendations for places where the beach can be experienced at its best. We also include a handful of cruise lines that offer smaller boats, marinas, and itineraries that are customized for the beach enthusiast. What all of these world-class destinations, beach resorts, and cruises offer is access to remarkable (and frequently remote) locations and a range of physical, cultural, and educational activities that will engage the beach aficionado, as well as unique vantage points for the coastal photographer, painter, or explorer. When it comes to catching a wave, diving beneath the water's surface, or getting into the spirit of the sea, it simply doesn't get any better than this.

Africa

Mombasa Serena Beach Hotel
Shansu Beach, Mombasa, Kenya
Telephone: (254) 11 485 721
FAX: (254) 11 485 453

Asia and the Far East

Amankila
Mangiss Beach
Bali, Indonesia
Telephone: (62) 363 413 33
FAX: (62) 363 415 55

Amanpulo
Pamalican Island, Philippines
Telephone: (63) 2 759 40 40
FAX: (63) 2 759 4044

Amanpuri
Pansea Beach
Phuket, Thailand
Telephone: (66) 76 324 333
FAX: (66) 76 324 100

Amanwana
Moyo Island, Indonesia
Telephone: (62) 371 222 33
FAX: (62) 371 222 88

The Oberoi
Medana Beach
Lombok, Indonesia
Telephone: (62) 37 063 8444
FAX: (62) 37 063 2496

Ritz-Carlton
Bali, Indonesia
Telephone: (62) 36 170 2222
FAX: (62) 36 170 1555

Australia

Bloomfield Wilderness Lodge
Queensland, Australia
Telephone: (61) 0 7403 59166
FAX: (61) 0 7403 59180

Thala Beach Lodge
Port Douglas, Australia
Telephone: (61) 0 7409 85700
FAX: (61) 0 7409 85837

The Caribbean and Mexico

La Samanna
St. Martin, French West Indies
Telephone: (590) 87 6400
FAX: (590) 87 8786

Maroma
Quintana Roo, Mexico
Telephone: (52) 114 987 44 729
FAX: (52) 114 98 84 21 15

Europe

Anassa
Polis, Cyprus
Telephone: (357) 6 322 800
FAX: (357) 6 322 900

Elounda Beach Hotel
Elounda, Crete, Greece
Telephone: (30) 8 4141 412
FAX: (30) 8 4141 373

Hotel Royal Riviera
St. Jean-Cap-Ferrat, France
Telephone: (33) 4 93 76 31 00
FAX: (33) 4 93 01 23 07

Hotel Splendido
Splendido Mare
Portofino, Italy
Telephone: (39) 0185 267 801
FAX: (39) 0185 267 806

Palazzo Sasso
Ravello, Italy
Telephone: (39) 0189 818181
FAX: (39) 0189 858900

Reid's Palace
Madeira, Portugal
Telephone: (351) 091 700 7171
FAX: (351) 91 71 7177

Indian Ocean

Banyan Tree Maldives
Vabbinfaru Island, Maldives
Telephone: (960) 443 147
FAX: (960) 443 843

Bird Island Lodge
Seychelles, Outer Islands
Telephone: (248) 323 322
FAX: (248) 225 074

Le Touessrok Hotel &
Ile aux Cerfs
Trou D'Eau Douce
Mauritius
Telephone: (230) 419 2025
FAX: (230) 419 2025

Middle East

Jebal Ali Hotel
Dubai, United Arab Emirates
Telephone: (971) 4 836 000
FAX: (971) 4 835 543

Ritz-Carlton Dubai
Jumeirah Beach
Dubai, United Arab Emirates
Telephone: (971) 4 211 954
FAX: (971) 4 287 870

North America

The Alexander
Miami Beach, Florida
Telephone: (305) 865 6500
FAX: (305) 341 6553

Delano
South Beach
Miami, Florida
Telephone: (305) 672 2000
FAX: (305) 532 0099

Little Palm Island
Little Torch Key, Florida
Telephone: (305) 872 2524
FAX: (305) 872 4853

Ritz-Carlton
Palm Beach, Florida
Telephone: (561) 533 6000
FAX: (561) 588 4202

Wequasset Inn Resort and Golf Club
Pleasant Bay
Chatham, Massachusetts
Telephone: (508) 432 5400
FAX: (508) 432 5032

White Barn Inn
Kennebunkport, Maine
Telephone: (207) 967 2321
FAX: (207) 967 1100

South America

Copacabana Place
Rio de Janeiro, Brazil
Telephone: (55) 21 548 7070
FAX: (55) 21 235 7330

The South Pacific and Hawaii

Bora Bora Lagoon Resort
Vaitape, Bora Bora
French Polynesia
Telephone: (689) 604 000
FAX: (689) 604 001

Hotel Bora Bora
Point Raititi, Bora Bora
French Polynesia
Telephone: (689) 60 44 60
FAX: (689) 60 44 66

Kahala Mandarin Oriental
Honolulu, Hawaii
Telephone: (808) 739 8800
FAX: (808) 739 8800

Manale Bay Hotel
Lana'i City, Hawaii
Telephone: (808) 565 7700
FAX: (808) 565 2843

Ritz-Carlton
Kapalua, West Maui
Hawaii
Telephone: (808) 669 6200
FAX: (808) 669 2028

Vatulele Island Resort
Vatulele, Fiji
Telephone: (61) 02 9326 1055
FAX: (61) 02 9327 2764

Beach and Sea Cruising

Seabourn Goddess I and *II*
Cunard Line Limited
Telephone: (800) 929 9391
FAX: (305) 463 3020

Seabourn Ships
(*Pride, Spirit,* or *Legend*)
Cunard Line Limited
Telephone: (800) 929 9391
FAX: (305) 463 3020

M/S Paul Gauguin
Radisson Seven Seas
Telephone: (800) 285 1835
FAX: (402) 431 5599

M/S Song of Flower
Radisson Seven Seas
Telephone: (800) 285 1835
FAX: (402) 431 5599

Photograph Credits